TALL TALES & HALF TRUTHS
OF PAT GARRETT

TALL TALES & HALF TRUTHS
OF PAT GARRETT

JOHN LeMAY

THE
History
PRESS

Published by The History Press
Charleston, SC
www.historypress.net

Cover photographs courtesy of the Historical Society for Southeastern New Mexico. Back cover illustration of Garrett by Lea F. McCarty.

First published 2016

Manufactured in the United States

ISBN 978.1.46713.545.0

Library of Congress Control Number: 2015958232

Notice: The information in this book is true and complete to the best of our knowledge. It is offered without guarantee on the part of the author or The History Press. The author and The History Press disclaim all liability in connection with the use of this book.

In memory of the Honorable John J. Halvorson,
another notable Roswell lawman

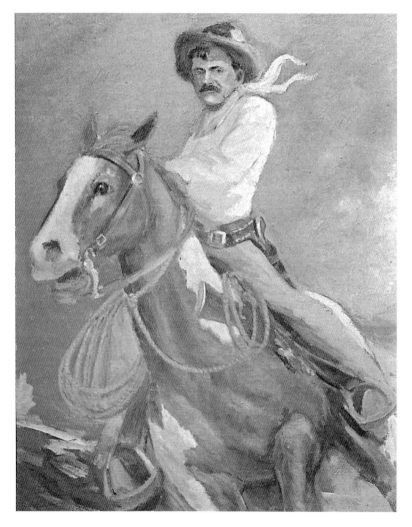

Artist Lea F. McCarty's rendition of Pat Garrett. *Author's collection.*

CONTENTS

ACKNOWLEDGEMENTS

For their assistance in writing this volume I'd like to thank Megan Laddusaw and Jose Chapa of The History Press, Robert Estep and Drew Gomber of the Lincoln County War Facebook group for answering questions, as well as researchers and historians Gary Cozzens, Lynda Sanchez, Morgan Nelson and Elvis E. Fleming. For photographs I'd like to extend a special thank you to Philip Nelson and the Historical Society for Southeast New Mexico, hereafter referred to as HSSNM in photo credits. Located at 208 North Lea in Roswell, New Mexico, the Archive Building for the HSSNM serves as Southeastern New Mexico's greatest repository of historical collections comprising near endless photographs and historical writings. Nearly all of the material in this book came from the Elvis E. Fleming Research Room; for appointments to research please call (575) 622-8333 or visit online at www.RoswellNMHistory.org.

INTRODUCTION
THE CURSE OF BILLY THE KID

Who wants another Billy the Kid story?
—C.L. Sonnichsen to Leon Metz

Another tired re-tread on Pat Garrett chasing down Billy the Kid. Aren't there enough of those already? Well, while there are plenty of books about Pat chasing the Kid, most are focused squarely on the latter rather than the former. But no, this book is not merely another tome about Pat capturing Billy at Stinking Springs or shooting him down at Fort Sumner. For that, one only need look elsewhere and they will find it easily. As was done in *Tall Tales and Half Truths of Billy the Kid*, this tome turns the limelight on Garrett's more questionable exploits—whether the Kid was included in them or not. Most are aware already of the numerous tall tales that claim Garrett helped to fake his friend the Kid's death, but even more bizarre are the stories that the man who killed the Kid in Fort Sumner wasn't Garrett at all. Or that the bad luck Garrett suffered after the famous killing was really the result of the "Curse of Billy the Kid."

Garrett's biographer Leon Metz once wrote, "To most folks, slaying the Kid was the only thing Garrett did that was worth mentioning."[1] This of course, as Metz argued, was not the case. Metz also muses, "Since reading [*Saga of Billy the Kid*], I've often wondered what might have happened had [Walter Noble] Burns ignored the Kid and written *The Saga of Pat Garrett* instead…Would it have made Garrett a folk hero?"

Actually, considering his longer lifespan, poor Pat could have made a far better dime novel hero than the Kid, and sadly, books focusing on the Kid outnumber books solely on Garrett by fifty to one (though one really can't have a book about one without the other).[2]

As with any intriguing dynamic between a hero and a villain, there exist some interesting similarities between the two. Both are considered heroes by some and villains by others, depending on the teller of the tale. The divide, it would seem, was both racial and generational. In the early days Pat Garrett was almost always the hero of the story. Racially speaking, most Hispanics regarded the Kid as a hero during the era of his adventures and Garrett as the villain. Conversely, Anglos painted Garrett as the hero and the Kid as the villain, exceptions being those who fought on the Kid's side of the war, such as George Coe, and also settlers like John Meadows (who it should be noted was partial to both men).

As for other similarities between the two, both were known to be positive presences at the dances, then called *bailes*, noted for their dancing and jovial attitudes. Both were popular with women, Billy for his roguish charm and Pat for his impressive height and his southern manners. Yginio Salazar once said of Billy that he had "the soft voice of a woman," and a reporter from the *Las Vegas Optic* also said the exact same thing about Garrett.[3]

Garrett's early years were not dissimilar to the Kid's, as Garrett lost his mother in his teens at the age of seventeen, and his youth is somewhat obscured by the mists of time. There are also rumors that Garrett killed a black man in either eastern Texas or Louisiana, but they have never been verified, much like many of the Kid's killings. Some even whispered that Garrett had a wife and a small family that he had abandoned in Texas. C.L. Sonnichsen writes that "[Garrett] lived an unwritten chapter of his life in Sweetwater, where some people are said to claim kin with him."[4]

Some even said that Pat was once in the "same profession" (cattle rustling) as the Kid. "Pat Garrett rustled as many cattle as Billy ever did," one old-timer remarked.[5] Among other notable personalities to make this same claim were Yginio Salazar and Susan McSween Barber, who said, "During conversations we had Billy always said Pat was a cattle rustler and had stolen plenty of cattle while living in Ft. Sumner."[6] Once, in June 1899 during his tenure as sheriff of Dona Ana County, Garrett arrested Juan Montenegro on a robbery charge, and later Montenegro claimed that Garrett stole four twenty-dollar gold pieces off of him during the arrest. Whether any of this is true, of course, can no longer be proven.

In contrast to the Kid, Garrett was tall and dark, and the Kid was short and light complexioned. In terms of museums and monuments, there have been three museums dedicated to Billy the Kid in New Mexico and one in Texas. There are no museums dedicated to poor Pat. Not far from El Paso, where Pat once prominently reigned as customs collector, there exists a bronze statue dedicated to Billy the Kid in nearby San Elizario. Ironically, Billy may have only visited San Elizario in the pages of Pat's largely fictitious *Authentic Life of Billy the Kid* but not in real life. Pat does at least have a bronze statue in his honor in Roswell, New Mexico, the town he called home when he killed the Kid.

Though both men died of gunshot wounds—or "with their boots on," as old-timers would say—their funerals were quite different. Billy had a Christian burial, and Garrett an agnostic service as per his wishes. Like the Kid, neither did Pat always rest peacefully in the grave. Though fewer threats were made to dig him up, he was disinterred in 1957 after vandals had destroyed his daughter Ida's tombstone, and the Garrett family was transferred from the Odd Fellows Cemetery to the Masonic Cemetery across the street. Strangely, fewer people flock to Garrett's grave to take pictures and pay their respects than they do the Kid's. And unlike the Kid, men never surfaced after Garrett's death claiming to be him. Perhaps it was because

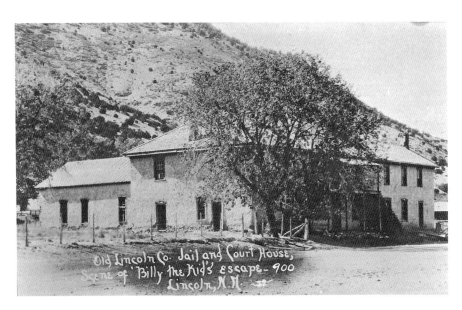

The famous Lincoln County Courthouse, the setting of much of the action in the dramatic lives of Pat Garrett and Billy the Kid. *HSSNM, #484.*

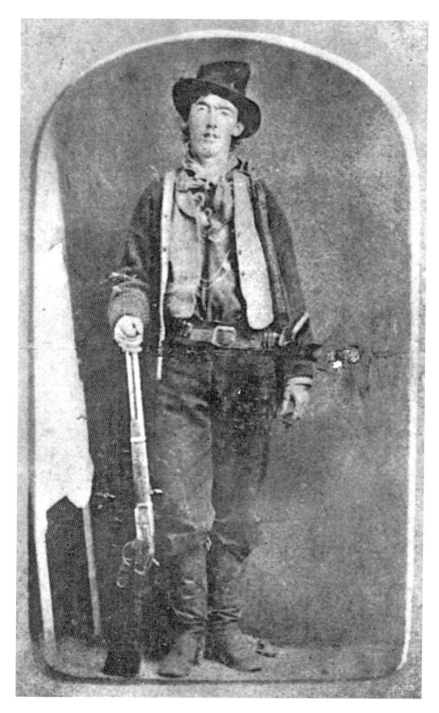

The well-known tintype of outlaw Billy the Kid. *HSSNM, #2195A.*

Garrett's body was seen by "thousands of people" when he laid in state and he died in a less romantic era on the cusp of modernism.

An article published shortly after Garrett's death stated that "he was always calm, cool, dignified and retiring, and seemed disposed to compromise personal affairs rather than to resort to the gun."[7] And indeed he didn't always resort to the gun in anger; sometimes he threatened to whip people with ropes or his fists instead. Actually, in all likelihood, Garrett was quicker to violence than the Kid (Garrett threatened to kill his own brother-in-law over an estate issue after the death of his father). A disgruntled ex-partner out to discredit Garrett once claimed that he exiled Garrett because the other cowboys feared being "murdered in their sleep." Though the latter's remarks were simply slander, Garrett did in fact bludgeon a political detractor of his, W.M. Roberts, unconscious with the butt of his gun in 1882.

A particularly nasty apocrypha about Garrett's temper stated that he blinded his infant daughter, Elizabeth, with his thumbs in a drunken rage. The tale was in no way remotely true, and Pat's relationship with Elizabeth was likely the most tender of his life. He was nothing but patient with young Elizabeth, who grew up to be a renowned songstress and write the state song "O' Fair New Mexico." In contrast to the tender relationship with Elizabeth is a humorous story relating to either his first born, Ida, or son, Dudley Poe, told by a neighbor by the last name of Carper. As Carper and Garrett toured the latter's ranch, on which there were several irrigation ditches, one of Garrett's offspring was constantly underfoot. Garrett warned her (or him) that he would kick her into a ditch if she didn't quit making a nuisance of herself. When she failed to do so, her father, as promised, kicked her into the ditch. She emerged dripping wet, and Carper quipped, "So he did kick you in the ditch." She replied, "Yes, I didn't think the old [cuss? bastard? sunnavabitch?] would do it."[8]

This incident took place at a time when Garrett was involved in a well-thought-out plan to irrigate the Pecos Valley. The scheme eventually panned out quite successfully, but by this time Garrett had since been edged out by new, more powerful investors. Such was his luck, and many scholars agree that Pat had a great deal of misfortune after killing the Kid in 1881. Almost all authors love to weigh in on the "Curse of Billy the Kid" in some way or another. One even tried to allege Elizabeth Garrett's blindness was due to the curse. In "The Tragic Life of Pat Garrett," Joe Heflin Smith writes, "That episode in Pete Maxwell's darkened bedroom [where Garrett shot the Kid] sent Pat Garrett down a lonely, frustrating trail, a trail filled with political and business failures, a break with his friend, Teddy Roosevelt, the

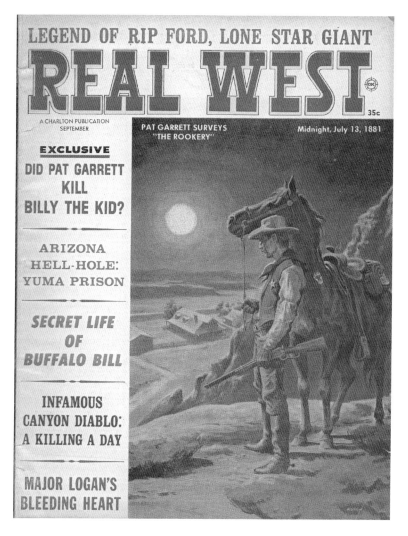

A painting of Pat Garrett surveying Fort Sumner adorns the cover of this 1966 edition of *Real West. Author's collection.*

loss of the best job he'd ever had, humiliation at Wildey [*sic*] Wells, the agony of a blind daughter and, finally at the last, a bullet in his back." In the article "The Mysterious Death of Pat Garrett," Margaret Page Hood relates the recollections of an old-time Mesilla newspaper editor who said, "After Billy's killing things went wrong for Pat. Nothing he touched turned out right. The Kid's native friends, superstitious devils, shook their heads knowingly." A good example of this superstition regarding the Kid comes from Pete Maxwell. Shortly after the shooting, when it came time

to sell the Maxwell Ranch to the New England Cattle Company, a hitch arose in the sale when Pete informed the buyer he could not sell one of the horses, specifically Old Don, which Billy used in his flight to freedom from Lincoln, because if he did, "Billy, dead these three years, would rise up in his grave and curse me."[9]

Many also like to tie in Pat's own mysterious death with the "curse." Pat was shot by either Jim Miller or Wayne Brazel over a feud involving goats grazing on Garrett's land. For those who choose Brazel as the killer, some like to poetically claim that Brazel was twenty-one years old when he shot Garrett to draw parallels with the Kid. This he was not; he was thirty-one, though he did, like the Kid, favor wearing sombreros, was well mannered and rarely drank alcohol. Some also mistakenly claim Jesse was the son of W.W. Brazel, considered by some a friend of the Kid's. Those who think that assassin Killer Jim Miller was the real gunman like to recall that lore states that Miller so far had "twenty notches" on his gun and that Pat Garrett made twenty-one (the number of men killed by the Kid in legend). The greatest irony in the nonexistent "curse" would have to be the goats that caused the feud and brought Garrett home and, perhaps, full circle. The Hispanics called Billy the Kid *El Chivato*, or the "young goat," and it was indeed an argument over some kidding goats that finally caused Garrett to go for his gun, prompting Brazel to shoot him in "self-defense," whereas Garrett's autopsy showed he was shot in the back of the head. Perhaps it really was the Curse of Billy the Kid, or rather, the Curse of El Chivato?

This so-called curse would continue to plague Garrett even after his death in print, when many old-timers were interviewed about "the days of Billy the Kid." For many years, there was a near equal divide between old-timers who spoke positively of Garrett and those who didn't. While his friends never denied he had a temper, they also claimed him to be the most honest individual they had ever met. Those who despised him feared being shot in the back by him. Despite having once sheltered one of Garrett's sworn enemies from the sheriff, the great western novelist Eugene Manlove Rhodes admired Garrett and made him the hero of his most acclaimed novel, *Paso Por Aqui*, loosely based on the Albert Fountain mystery. For that matter, Garrett was treated mostly well in early literary accounts of the Kid. This began to shift only upon publication of *The Saga of Billy the Kid* by Walter Noble Burns, who chose to make the Kid the hero rather than Garrett. Though Garrett didn't spend his time twisting his mustache belting out maniacal laughs in *Saga*, the Kid was still clearly the sympathetic hero. Leon Metz surmised, "Perhaps more than any single person, other than the

Kid himself, Burns, in his romanticized *Saga*, flagrant with error, distortion, and misinterpretation became Garrett's nemesis."

Like that for Billy, the first volume ever written solely devoted to Garrett was completed shortly after his death by El Paso newspaperman John Milton Scanland in *The Life of Pat F. Garrett and the Taming of the Border Outlaw*. Though informative for the first few chapters, it slowly devolves into a rehash of Garrett's *Authentic Life of Billy the Kid*. The first real biography on Garrett is the oft forgotten and underrated *Pat Garrett* (1960) by Richard O'Connor, a somewhat more fanciful precursor to Leon Metz's more scholarly *Pat Garrett: The Story of a Western Lawman* (1974). Released a few years prior to that was Colin Rickard's *How Pat Garrett Died* (1970), devoted in full to the conspiracy that took his life.[10] More recently, in 2011, Mark Gardner composed an exemplary dual biography of Garrett and the Kid in *To Hell on a Fast Horse*. This volume you now read stands on the shoulders of those giants, but it isn't its intent to emulate them. It exists rather to fill in the blanks of Garrett's life

WALTER NOBLE BURNS WEIGHS IN ON PAT GARRETT

During the late 1920s, Walter Noble Burns engaged in an intriguing correspondence with Lincoln County War researcher Maurice G. Fulton wherein the duo debated the merits of Burns's new book: The Saga of Billy the Kid. *In 1928, Burns wrote this letter, which speaks in depth about Pat Garrett:*

> I am not altogether sure that I am open to the charge of having painted Pat Garrett as a hero. I heard Garrett damned up and down by many people in New Mexico as a coward and a cold blooded murderer. I have touched on this side of his character in my book. But whatever we may think of his courage, his bad faith and his disloyalty to his friends, Garrett carried out the job he undertook with courage and determination not far from heroic when we take into consideration all of its difficulties and dangers. In my estimation Garrett was a brave man—he must have been a brave man to do what he did—and what he did, it seems clear to me, resulted in a new era of law and order in New Mexico.

with the tall tales and half truths the other authors neglected, and rightfully so, for more factual details. As such, this author has done his best to only relate the commonly re-tread history only when necessary, as the story of Billy the Kid, Pat Garrett and the legendary village of Lincoln has been old for a long time and was even considered so all the way back in the late 1880s. When Garrett's good friend and ghost writer for *Authentic Life*, Ash Upson, was asked at that time to jot down his reminisces on Lincoln, he replied, "Do you think there would be any consanguinity between the results of putting old tales in new dress and putting old wine in new bottles? What can I relate of twenty five years ago in Lincoln County that has not been printed by more eloquent pens?"[11]

With the words of wise old Uncle Ash firmly in mind, and with no more ado, here are the *Tall Tales and Half Truths of Pat Garrett.*

1
BEFORE HE KILLED THE KID: 1850-79

For a gunman, Pat Garrett was destined to live a long life.
–Leon Metz, Pat Garrett: The Story of a Western Lawman

Before he was a famous New Mexican, Patrick Floyd Garrett[12] was a southern gentleman. Garrett was one of seven children born to John Lumpin Garrett and Elizabeth Garrett in Chambers County, Alabama, on June 5, 1850. Eventually, the family moved to Louisiana, where John owned a medium-sized cotton plantation, though many yarn spinners of the 1950s tried to paint it as a sprawling estate. However, Claiborne Parish where it was located was the richest district in the entire state. During this time, young Pat clerked in the plantation store and also became proficient at hunting squirrels, rabbits and other small game. One tale gives an indication of Pat's temper, stating that he once walked three miles in the snow to punch a neighbor boy in the face for beating his dog,[13] though this tale is probably just as fanciful as Billy the Kid stabbing a boyhood friend in the streets of New York.

Southern to the bone, John Garrett gunned down a northern sympathizer on the front steps of the county courthouse.[14] Bizarrely, the man lived and never pressed charges, though John died a year later in 1868. After this, the Garrett estate came under legal turmoil, so much so that Pat became enraged enough to threaten the administrator's life. This man also happened to be his brother-in-law. With his mother having passed away in 1867, and there being nothing left for Pat in Louisiana, he packed up and headed west

in 1869. Some say he worked as a cowhand in Dallas County, Texas, and he possibly joined several cattle drives from Eagle Lake to Kansas.

Like the Kid, the next few years in Garrett's life are something of a mystery with a "Pat Garrity" being jailed for "intent to murder" in Bowie County, Texas, in March 1875. He escaped his confinement and went on the run.[15] Though it's possible that Garrity isn't actually Garrett, record keeping during the Old West was quite careless compared to what it is today. There also exists a legend that at this time Garrett was arrested by Wyatt Earp. This tale comes not from Garrett but from Earp, who alleges that he and Doc Holliday once arrested Garrett and some other cowboys when they caused some trouble near Dodge City, Kansas.[16] Earp said that Garrett was one of several men under the leadership of Tobe Driskill and Ed Morrison—who had a feud with Earp—who rode through the town firing their guns and shooting out windows and streetlights until it was pitch dark. The marauding cowboys were then arrested easily by Earp with the assistance of Doc Holliday, and they were marched off to the jail. However, back then Garrett was a "nobody," the only thing that stood out about him being his sizeable stature. It's curious that Earp would remember his name, and many say this incident happened when Garrett was already planted in Fort Sumner in September 1878.

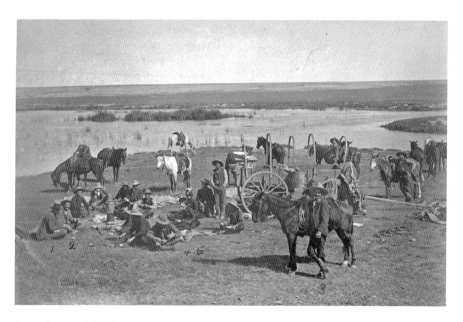

A rare image of Pat Garrett (the man marked "1") on the trail, albeit in Roswell well after his buffalo hunting days in Texas. *HSSNM, #566.*

More reliable sources say that, rather than venturing up to Kansas, Garrett stuck to Texas, where he began a career as a buffalo hunter. Sporting a bushy beard rather than a bushy mustache at the time, Garrett threw in with a lot of characters by the names of Skelton Glenn and Luther Duke, the trio forming a partnership in buffalo hunting. The trio's main haunt when they weren't on the trail was Fort Griffith, one of the wildest towns in Texas along the Rio Brazos. It was in this town where Garrett presumably fell in love with gambling, guns, women and whiskey.

GARRETT'S FIRST (OR SECOND) KILL

Garrett's "first killing" isn't as legendary as Billy the Kid's, as there aren't as many variations of Garrett's, but it was still a much talked about affair among the "old-timers."[17] The young victim of Irish heritage, Joe Briscoe, was a fellow Louisianan whom Garrett had instructed in the buffalo hunting trade. One cold night, as the hunting party sat around a fire, Briscoe, who had been trying to do his laundry in a cold dirty river, came up to warm his hands, complaining all the while about the cold. Garrett remarked that only a "damned Irishman" would be so stupid as to try and wash anything in a muddy river. This remark sent Briscoe into a frenzy, and he began charging Garrett. Being much taller than Briscoe at six feet, five inches, Garrett fended off his attacks with such ease that he began to feel sorry for Briscoe. Undeterred, Briscoe picked up an axe and began to chase Garrett around the camp. Getting his hands on his trusty Winchester he purchased at Fort Griffith, Garrett blew Briscoe away. The young man fell back right into the fire that had more or less started the confrontation.

Garrett was reportedly very upset over the killing and spent the whole rest of the night riding his horse alone. The next day, he turned himself in at Fort Griffin, but as it was considered self-defense, Garrett was charged with nothing. Naturally, as with the Kid's killings, there are alternative tales depending on the teller. In one version, the dying Briscoe calls to Garrett, "I'm dying, Pat. Won't you come over here and forgive me?" The words were said to haunt him till the end of his days.[18] Other anonymous yarn spinners also attest that Garrett was merely drunk and overbearing and shot poor Briscoe for no reason. Frank Lloyd said, "He really killed the kid to keep from paying him his wages."[19]

Bert Judia, one of Garrett's detractors, tells Eve Ball that he knew Skelton Glenn and that Glenn told him he and Garrett came upon a "half-grown" boy washing something in a "buffalo wallow" just west of Tivan, New Mexico. Pat asked the kid, "Do you expect to get anything clean in that muddy water?"

"It's my handkerchief," the young man responded a bit too snidely.

"Pretty smart, ain't you?" And just like that, Garrett shot him dead.[20]

Pioneer John Meadows reportedly told C.L. Sonnichsen that it was Glenn himself who Garrett shot after being chased with an axe. Meadows also claims that once Garrett turned himself in and returned to camp it had been raided by Indians. In effect, Meadows grouped a famous raid story (which occurred at a later date) in with the killing, which most certainly was not that of Skelton Glenn, who it should be said outlived Garrett.

The raid story Meadows spoke of was the "Hunter's War" in Texas, near present day Lubbock. There, Garrett, Glenn and around fifty others fought a battle against a band of Comanches. On February 1, 1877, a group of Comanches raided Glenn's camp, destroying and burning about eight hundred buffalo hides (around $1,000 in damage) and stole the horses. When Glenn and Garrett, both of whom were absent during the raid, found the campsite, Glenn was enraged and insisted that they track down the Comanches. The result was the battle at Yellow House Canyon, which concluded with the white men running from the Indians with tails firmly tucked between legs.

Pat parted ways with his partners during a fateful stop in Fort Sumner later that year, reportedly after the trio was flat broke from a gambling spree in Tascosa, Texas. Ironically, one of the first people Pat spoke to was Pete Maxwell, son of legendary land owner Lucien Maxwell. Pat was said to have groveled for a job from Pete, who took mercy on him and asked, "What can you do lengthy?"[21] In a twist of fate, four years later, Garrett would be the one in a position of power over Maxwell, using him in his search to kill Billy the Kid. In fact, Garrett would barge in and awake the sleeping Maxwell in his bedroom on the night of July 14, 1881, only a few minutes before shooting the Kid in the same room. Maxwell himself, running out of the room, was almost shot by Garrett's deputy John Poe who thought him Billy the Kid. But before the perennial tables had turned, Maxwell was Garrett's boss.

WHEN GARRETT MET THE KID

Of course, alternate sources also claim Billy was the first person Pat met in Fort Sumner. One tale says Billy first met a haggard, down on his luck Pat Garrett, and his partner Skelton Glenn, in an unnamed bar. At the time, Pat was without boots and wearing some trousers too small for his long legs.[22] When the Kid looked him over, he reportedly said, "You may be a man, but you sure don't look like one." Billy let the pitiful Garrett join his gang and "took Pat to the trader and outfitted him."[23] Old-timer Frank Lloyd likewise said, "Pat went to Fort Sumner, was broke, and Billy The Kid bought him some clothes." In *Triggernometry: A Gallery of Gun Fighters*, Eugene Cunningham quotes an unnamed sheriff as saying, "I remember one time he [Billy] gave Pat Garrett his horse and saddle and bedding and had to steal another outfit for himself." John Allred, another of the duo's Lincoln County contemporaries, also claimed that Billy had been a friend to Pat the moment he stepped into the county and even secured a horse for him.[24]

George W. Coe, a usually if not always reliable witness/participant to the Lincoln War and compatriot of the Kid, also claimed that the duo were good friends. Paulita Maxwell, the Kid's alleged girlfriend, told Walter Noble Burns, "Pat Garrett was as close a friend as Billy the Kid had in Fort Sumner and was on friendly terms with every member of the Kid's gang. When we saw Pat and Billy together we used to call them 'the long and short of it.' He ate, drank and played cards with the Kid, went to dances with him and gallivanted around with the same Mexican girls. I have seen them both on their knees around a horse blanket stretched on the ground in the main street gambling their heads off against a monte game." Eventually, Pat and Billy were said to collectively be known as Big Casino and Little Casino, often seen gambling in the streets together, and when one was down on his luck the other would come along to back him.

An apocryphal tale appearing in the article "The Untold Saga of Pat Garrett," likely concocted by the author Earl Seavers rather than any old-timer, says that Billy and Pat first met at a dance in Silver City wherein the former saves the latter's life. As Pat dances with a "Mexican beauty" named Lucinda Orenlas, he is challenged by the rapscallion rawhide Noah Moffett. "Reach, you yella coyote!" challenges Moffett to Garrett, who is reputed to be "slower than molasses in January" on the draw.

Coming to the rescue is Billy the Kid, who shouts, "Everybody says you've got a big mouth, Mr. Moffet, when it comes to riding somebody who don't

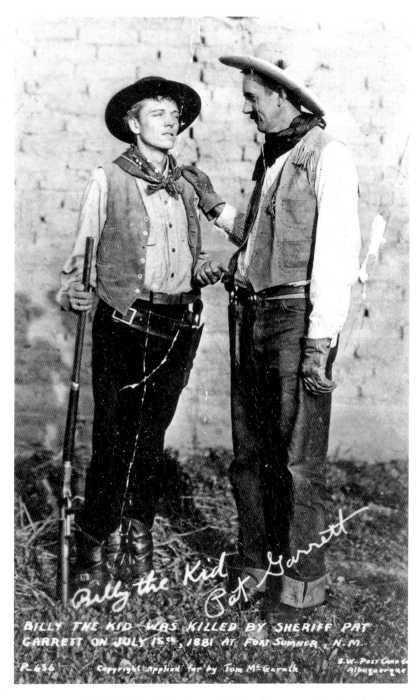

Actors pose as Billy the Kid and Pat Garrett in friendly conversation for this vintage postcard. *HSSNM, #5203.*

know which end of a gun the smoke comes out of. Like right now, trying to egg Garrett into a draw you know doggone well he can't make. Now suppose you prove to these people, here, they got the wrong idea. That you ain't scared to draw on anybody. Such as me."

Moffet's face turned white as a sheet, and clearly frightened by the Kid, he tried to talk his way out of the situation. The Kid and the excited crowd encouraged Moffet to draw on the Kid. When he finally did, Billy blew him away. "I'm 'bliged," Garrett said, shaking hands with his defender. Thus a beautiful friendship that included hunting game in Old Mexico, hours drinking and gambling at the Black Aces Saloon, exploring the ruins of old missions and even going on double dates together began. Or so it did according the fallacy-ridden article that also claims President Roosevelt didn't reappoint Garrett as collector of customs in El Paso in 1905 because he had learned that Garrett shot his best friend (the Kid) in the dark. Historically, Roosevelt was fully aware of Garrett's claim to fame, and it was one of the main reasons that he hired him.

JUAN LARGO

To return to more factual matters, such as Garrett's working for Pete Maxwell, Paco Anaya, who disliked Garrett, has a different account regarding how Garrett joined up with the Maxwell outfit. Anaya said:

> One day about ten o'clock in the morning we were branding when Pat Garrett arrived...and entered the corral, and he was watching how we branded the calves. He was very poorly dressed and looked like a tramp. He was wearing a very soft cap, a very torn coat, suede pants, and shoes like a moccasin. After watching us work for a while, he offered to hold a calf by the feet, and then he kept helping us until almost 11 o'clock...The next day he came again to the corral, and entered without anybody saying anything to him, and he set up to help us. He helped us until the branding was finished, which took two days. This was all that Pat Garrett worked for Don Pedro [Pete Maxwell]. On the cattle ranch, he was never hired on as a cowboy.

Whatever the case, soon Pat was known as Juan Largo ("Long John")[25] and was a popular fellow with the ladies, much like the Kid. His height was a

source of amazement for the locals, and Garrett's future friend Ash Upson would one day write in an article that "in addition to being long headed [Garrett] is also long legged, his full height being somewhat under ten feet—I have forgotten the exact measurements."[26] Garrett soon married Juanita Gutierrez sometime in 1877 via a justice of the peace. Precise details on Juanita, from her actual name (which several say was Martinez) to the cause of her death several weeks—or months, depending on the source—later are unknown. Most assume she died from complications of a miscarriage, though folklore stated that she died of a broken heart, not having been properly married in the Catholic Church. Paco Anaya tells a different story in which he and Billy attended the wedding. At the reception baile, Anaya said the bride had an "attack" (as in a fit or medical episode) and had to be carted off to another room. "The next day she died, without Pat having the pleasure of being with her after the dance. The wedding of Pat was very sad."

It is presumed that Garrett later married Juanita's sister, Apolinaria Gutierrez. The two fell in love after Pat became intensely ill in a snowstorm and Apolinaria nursed him back to health. They were later married in Anton Chico (in the church this time) on January 14, 1880. In *Fabulous Frontier*, William Keleher wrote:

> *Back in Fort Sumner with his bride, there was much whispering among the people of the village, and many an old woman raised an eye toward heaven because, it was said, that Pat Garrett had been married not so long before to Juanita of the same village and that Juanita Garrett had pined and worried because she had "not been married at the altar"; believed that her marriage was invalid in the eyes of the church. Juanita, they recalled, had died suddenly while attending a dance with Pat Garrett in Fort Sumner, remorseful to her dying moment that her marriage had been performed by a justice of the peace instead of "el padre."*

Some say Pat's getting tied down to Apolinaria also cut down on his hurrahing with the boys, and thus he and Billy drifted apart. Pat had also quit working for Pete Maxwell by this time, possibly over a dispute, and opened up some sort of eatery. Paco Anaya specifically claims it was butcher shop that he opened with the notorious Barney Mason using a steer stolen from Anaya's family. Garrett furthermore went on to kill three cows that didn't belong to him, or so Anaya says. After being

confronted by the Anayas, Garrett said he would pay them for the meat, but he never made good on his promise and so Billy was sent in to talk to Garrett. Billy's talk with Garrett didn't result in him paying for the stolen beef either, but the fact that the Kid was sent to talk to Garrett is interesting.

Later Billy was said to have remarked, "This Pat Garrett is a bigger thief than us. This one came over from Texas because he didn't fit, even on the Llano Estacado." This would seem to imply that like Billy, Pat rustled the occasional steer, maverick or not. "They were carrying on the same line of business," Pete Maxwell was said to say of Garrett, and Susan McSween said something similar, as did Vicente Otero.

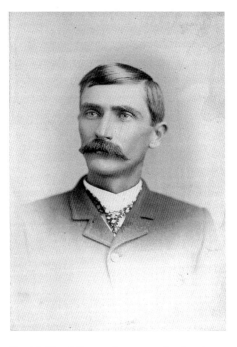

Patrick Floyd Garrett in a portrait taken in Las Vegas, New Mexico, around the time he married Apolinaria. *HSSNM, #1925.*

Pat and Mason eventually gave up on the butcher shop, and Pat opened a small cantina with Sam Lock, which also didn't last for long, if it ever existed to begin with. More certainly, Pat became a bartender in Beaver Smith's saloon. Somewhere in this murky point of history, apocryphal tales aside, is where Garrett for certain met Billy the Kid and also became a spectator to the Lincoln County War, raging south of Fort Sumner for a good two years over various feuds. The Kid was said to be seen talking to Garrett often in the Beaver Smith saloon, and Miguel Antonio Otero claimed, "For nearly two whole years Pat Garrett was a personal friend of the Kid."

FRIENDS AND FOES OF PAT GARRETT: SEABORN T. GRAY

An interesting bit of trivia that most historians neglect to mention (excluding Gary Cozzens, who revealed this information in his book Capitan, New Mexico) is that Garrett was first cousins with the founder of Capitan, New Mexico, Seaborn T. Gray. Like Garrett, Gray was born in the state of Alabama (in Coosa County near Chambers) in 1851 and eventually moved with his family to Louisiana. In 1884, cousin Pat urged Gray to move to New Mexico, where he was ranching in Lincoln County. Gray's daughter, Nellie B. Reily, said in a Federal Writers' Project (FWP) interview, "Pat Garret was a cousin of my father. He came to Grapevine, Texas to visit us in the early spring of 1883. He had a cattle ranch on Little Creek, which is now part of the old 'V' ranch, near Ruidoso...He persuaded my father to move to New Mexico and bring his cattle where there was lots of good feed and water and open range. Cousin Pat mapped out the trail we were to travel as he had hunted Buffalo out on the plains and had made the trip several times and knew all the watering places."

And so the family traveled to New Mexico and even stopped to visit Billy the Kid's grave along the way in Fort Sumner. "I remember it had a board at the head with his name, age and the date he was killed. He had only been dead two years then," said Reily. Before settling in what would eventually become Capitan, the Gray family camped out in a tent in the Garretts' "backyard."

Initially called Gray after its founder in 1894, the little settlement started by Seaborn Gray eventually became Capitan. As the town is the home of Smokey Bear, can one then argue that Pat Garrett had a hand in creating two of New Mexico's greatest legends: Billy the Kid and Smokey Bear?

2
SHERIFF OF LINCOLN COUNTY: 1880

Perhaps it was a pity Garrett was not much of a man for reading books.
Otherwise he would have realized how glorious became the legend of Robin
Hood, how infamous the Sheriff of Nottingham.
–Richard O'Connor, Pat Garrett

Naturally, his position as a bartender was not what led Lincoln County residents to elect Pat Garrett as their new sheriff. It was as an act of daring involving an Indian raid. Sometime in the late 1870s, a party of Comanches absconded with a herd of horses from a Roswell ranch. A posse of men, including Garrett, set out to get them back. When other men turned back on the hard trail, Garrett and a few others prevailed. A week later, Garrett and the few remaining men marched into Roswell with the horses that were still alive[27] and a "sack full of moccasins," implying Garrett had killed a good number of the Comanches. This daring act caught the attention of the Roswellites, then part of Lincoln County. Of course, there is an alternative story of a great act by Garrett that caught the attention of Roswellites related by newspaperman Lucius Dills:

> *His* [Garrett's] *election…to the office of sheriff in 1880 was not due to any advance promises, but to the way in which he raced and stood off a band of irate citizens, intent upon hanging a Mexican, whom Garrett had been deputized to arrest, for killing an Anglo. The native*

was later tried and acquitted. This is an incident in the unwritten history of the Pecos Valley, and it convinced the continually victimized stockmen of the county that Garrett possessed the essentials for a real sheriff, and they acted accordingly.[28]

Among the "victimized" stockmen were cattle baron John Chisum, at the moment in the middle of an intense feud with Billy the Kid, and with him was Roswell patriarch and fellow southerner Captain Joseph C. Lea. With the backing of these two powerful individuals, Garrett was able to secure a nomination for sheriff of Lincoln County against George Kimbrell, who was reportedly soft on the Kid. One account had Garrett refusing the offer initially, claiming that his friend the Kid had been coerced into his outlaw career due to the Lincoln County War. Supposedly the Kid's "murder" of Joe Grant then changed Garrett's mind.

Getting rid of the Kid and his gang of rustlers would be the linchpin of the whole campaign. Other characters backing Garrett were J.A. LaRue, Lincoln saloonkeeper; Will Dowlin, who operated the famous Old Mill in Ruidoso; and James J. Dolan, the "villain" of the Lincoln County War and once the enemy of John Chisum. But as the old saying goes, "The enemy of my enemy is my friend," and both men wanted the Kid gone. Garrett was elected as sheriff of Lincoln County on November 2, 1880, and the hunt for the Kid was on. Soon cow camps were ablaze with talk of the inevitable duel, with bets being placed on who would win. "I heard men offer to bet that if the two men ever met, Billy would kill him. Everybody thought Billy the more dangerous man and the quicker and surer shot," Paulita Maxwell said to Walter Noble Burns. She also said that "nothing ever

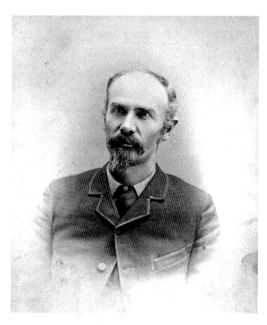

Captain Joseph C. Lea (circa 1887) was one of Garrett's most influential backers as the patriarch of Roswell, New Mexico. *HSSNM, #356C.*

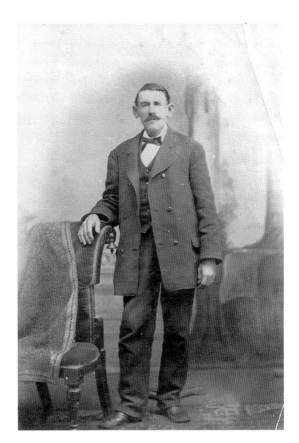

John Chisum, the "Cattle King of the Pecos," was another of Garrett's powerful backers. *HSSNM, #604D.*

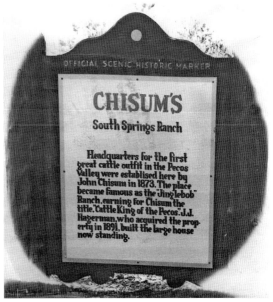

A historical marker detailing the history of Chisum's ranch. *HSSNM, #2976.*

gave Fort Sumner such a shock of surprise as Garrett's selection by the cattle interests to be sheriff of Lincoln County. He was familiar with all their old trails, their favorite haunts, their secret places of rendezvous and refuge."

CAPTURING THE KID AT STINKING SPRINGS

Garrett managed to track down the Kid and his gang only a month after winning the election. Garrett gunned down Tom O'Folliard, a member of the Kid's gang, in late December 1880. The dying moments of O'Folliard, shot outside in the snow and then drug inside a cabin, played out in a comically macabre scene wherein Garrett and the rest of his posse nonchalantly played poker as O'Folliard bled out. As O'Folliard lay dying, he would alternate between cursing Garrett and begging him to kill him to end his misery. At one point, Garrett looked up from his cards and chided O'Folliard by saying, "I wouldn't talk that way, Tom. You are going to die in a few minutes." And so he did.

Later, Garrett and his men carried O'Folliard's body in a pine casket to the Fort Sumner Old Military Cemetery and hoped the Kid would join him there soon. With no priests or clergymen present, Pat, not able to think of anything to say, nodded his head, and his deputies began to shovel earth onto O'Folliard's grave. Through this inauspicious beginning, Pat had taken the first steps to creating what would eventually be a monumental tourist destination.

By December 23, 1880, Garrett and his posse had tracked the Kid and his gang to a rock house at Stinking Springs. A shootout occurred, which took the life of one Charlie Bowdre, who would eventually be buried next to O'Folliard. The legendary exchange between the Kid (confined within the house) and Garrett as he cooked some bacon outside, the smell of which greatly tempted the starving outlaws, was quite comical.

"Come out and get some. Be a little sociable," Pat taunted.

Billy replied, "Can't do it, Pat. Business is too confining. No time to run around."

Earlier, the Kid and gang had boasted that they would drive Garrett's posse down the Pecos in fear. In a supreme zinger Garrett couldn't help but quip, "Didn't you fellows forget part of your program yesterday? You were to come in on us in Fort Sumner, give us a square fight, set us afoot and drive us down the Pecos." This sly statement also let the Kid know good and

A flier advertising Messila, New Mexico, the town where Billy the Kid was sentenced to hang. *HSSNM, #4043B.*

well that he had been snitched on by a "friend" who informed Garrett of the Kid's whereabouts. "Craving stomachs overcame brave hearts," Garrett later reflected.[29]

So Billy and the gang were captured, and in keeping with the introduction's promise not to re-tread the worn-out ground covering Garrett's escort of the Kid to Mesilla for trial and his eventual escape from custody, we shall turn our attention to other adventures had by Garrett during his tenure as sheriff, both before and after killing Billy.

SALOON BRAWL AT PUERTO DE LUNA

One of Garrett's more daring saloon encounters occurred before his capture of the Kid. The scene plays out so nonchalantly in some tellings that one could almost confuse it with a skit from a western comedy such as *They Call Me Trinity*. While drinking in Puerto de Luna, some of the local bad men took to taunting Garrett to arrest them, who politely declined as he had no warrants for them and thus didn't really care. Not getting the reaction they wanted, another more boisterous bad man, Mariano Leiva, went in and yelled, "No gringo dares to arrest me!" Garrett merely rubbed his mustache in boredom and kept on drinking in true Bud Spencer style.[30] Irritated, Leiva stomped outside and proclaimed to some onlookers that "even that damned Pat Garrett can't take me!" As he turned around to point back to the saloon, Garrett, now outside, knocked him down into the dirt. Leiva immediately shot at Garrett, missed and then was hit in the shoulder by a shot from Garrett's gun.

Garrett went back inside to collect his Winchester while Leiva was helped onto a horse. The town's deputy soon marched in to inform Garrett he was under arrest for the shooting. Garrett didn't seem worried and more or less ignored him. When he protested again, Garrett's deputy Barney Mason put his shotgun to the deputy's stomach and asked, "Shall I cut the son of a bitch in two, Pat?" The deputy promptly left, and Garrett remained unmolested.

As for Leiva, he was later found guilty on charges of assault with intentions to kill Garrett and fined eighty dollars.

CATCHING THE RED EYE

Another notable adventure centered around a saloon on a windswept plateau near Fort Sumner said to house a freckled outlaw tending bar. The man was said to have committed a murder back east and was worth a $1,200 reward. To be sure it was the right man, Garrett had to get a good look into his eyes,

The first two buildings in Roswell, New Mexico, owned by Captain J.C. Lea and also where Garrett's friend Ash Upson served as postmaster. *HSSNM, 376B.*

A view of Roswell, New Mexico, during the 1880s around the time that Garrett and his family lived there. *HSSNM, 376B.*

where a notorious red spot was supposed to be. Garrett went inside the saloon and advised his deputy not to shoot until they could see the red of his eye and that they should get a couple of drinks first so as to check the fellow out. "When a bartender is waiting on you he will never look you in the face until just as you raise your glass to drink." And look him in the eye Pat did, and there was the notorious red spot. Garrett immediately drew out his gun and told him to throw his hands up or he would shoot him. For a long while the outlaw kept his hands on the bar until he finally gave in and raised them. He was later hung in Las Vegas and thus executed. Garrett quipped, "So far as the outcome was concerned, he might about as well have gone after his gun."

GARRETT RUNS FOR THE SALOON

While playing cards in the park with some "old cronies" in Whittier, California, in 1945, famous writer C.L. Sonnichsen met an old-timer by the name of Abernathy. Abernathy told him a unique tale of Pat Garrett in the Lincoln County Courthouse, presumably sometime after the killing of the Kid. It revolves around Garrett constantly berating his deputy Jim Baird until he finally had enough. Sonnichsen writes:

> One day he [Baird] *slowly rose from the chair he was sitting in and told Pat he had enough of his razzing. Pat flavored it with profanity, and that Jim didn't like. He said he had stood for all such remarks that he was going to. Being officers of the law, they both wore six shooters. Jim told Pat they would go downstairs and when they reached the ground, one would turn right and the other left. When they came in sight of each other they would start shooting. Jim circled the building but found nothing to shoot at. He learned later that Pat had kicked up dust as he ran to the nearest saloon.*

PAT GARRETT—THE TERROR OF EVILDOERS ACROSS THE LAND!

In contrast to the previous cowardly story is this tale in which Garrett lives up to his name—bestowed to him by sensational newspaper articles—as the "terror of evildoers" across the land. According to Colonel Jack Potter, foreman of

the New England Cattle Company in Fort Sumner, Pat often used the J.H. Teets Store as an ambush spot of sorts to catch outlaws.[31] The spacious storeroom was about thirty feet long and had an adjoining warehouse separated by a door laced with bullet holes. "In fact, everything around the place seemed to have been shot up at some time," Potter wrote. Garrett and his men made use of the place to hide in the warehouse, where they spied on the customers through the bullet holes. Potter says one day when he spied a group of bandits nearing Fort Sumner, he rode to warn Garrett, who then took to hiding in his usual spot. As predicted, the bandits stopped in at the store where J.H. Teets made lengthy conversation with the men. When Garrett was satisfied that the men in question were the bandits Potter spoke of, he burst from the door and said, "You're covered, throw them guns down on the floor!" The bandits did as ordered and were arrested without a hitch. These weren't the only evildoers Garrett instilled with fear. One of Billy the Kid's *compañeros* who had been among those captured at Stinking Springs and spent most of his time bragging about the fact, Tom Picket, liked to pretend he was a bad *hombre*. When Pat came riding through town unexpectedly one day, Pickett ran off for the hills and didn't return until Garrett had left, much to the amusement of the townsfolk. From then on, he was said to have turned a new leaf as a quiet, respectable citizen.

PAT GARRETT PRESENTS AN 'AWARD' TO GOVERNOR LEW WALLACE

Billy the Kid once had a famous meeting with Lew Wallace, the author of *Ben Hur*, during his tenure as governor of New Mexico. As it turns out, so too did Garrett have an episode, albeit much more comical, with the governor. It was related by Garrett's daughter, Elizabeth Garrett, in the book *Reminiscences of Roswell Pioneers*:

> *Governor Lew Wallace was a friend of the cowboys and they were grateful to him for many kindnesses. They decided to show their gratitude by presenting him an Indian blanket, into which they had asked the Indians to weave their loyalty and appreciation in the bright colors which indicate such attributes. It was a beautiful day when they all gathered in Santa Fe at the Palace of the Governor's and the "long, lean, lanky cowboy" [Garrett] who had been chosen to make the presentation speech was all ready for it. The cowboys decided to keep the blanket at the foot of the line until called for by the spokesman. When the final*

Elizabeth Garrett, standing left, was an active member of the Roswell community. She died from a bad fall on a street corner in October 1947. *HSSNM.*

moment came the speaker, who was by this time in a "lather of sweat," stepped forward and said "Governor Lew Wallace of the Territory of New Mexico," swallowed hard, forgot his speech and delved into his pocket for it, stepped back at the same time on the toes of the cowboy just back of him, who in turn did the same and on down the line. The speaker discovered to his horror that he had left his speech in the pocket of his work clothes and decided to try again, "Governor Lew Wallace of the Territory of New Mexico," and again he stopped and gulped. At the third attempt the cowboys began to mutter words of warning to him and he finally turned in desperation and said, "Give it here, cowboys," walked up to the Governor, handed him the blanket and blurted out, "Here, Guv, take the damn thing for what it's worth."

FRIENDS AND FOES OF PAT GARRETT: BARNEY MASON

Barney Mason, Garrett's right-hand man and favorite deputy, was a fellow southerner born in Richmond, Virginia, just a few days shy of Halloween on October 29, 1848. Regarded as something of a comical ne'er-do-well, in Pat Garrett, Richard O'Connor describes him as "a born toady who liked to swagger in Garrett's lengthy shadow." Like the Kid, Mason was a man of small stature with a big ego.

Mason wandered into Fort Sumner in the late 1870s, and his inaugural killing there was that of John Farris. Supposedly, this occurred during a card game between Farris, Garrett and Mason, who shot Farris in the back. Mason and Garrett became fast friends, and the duo were even married in a double ceremony in the same church, leading some to believe that Mason's bride Juana Madril was Apolinaria's sister, though this is doubtful. Whatever the case, Mason was often referred to as Garrett's brother-in-law, and he named one of his sons Patrick.

Mason was present for many of Garrett's adventures tracking the Kid and once went undercover in White Oaks to try to bust up a counterfeiting ring the Kid was a part of. When the Kid discovered Mason, who was well known among outlaws, he merely claimed he was passing through town to scope out some horses to steal. Knowing him to be a shifty character associated with Garrett, the outlaws reluctantly let him go, but some strongly considered shooting him.

After the Kid's famous escape, Mason tracked him all over the villages of San Miguel County, and at one time while traveling with his wife via a horse and carriage, saw his quarry. In his fear, Mason was reputed to have hidden himself with his wife's shawl. Paulita Maxwell gleefully related this episode to Walter Noble Burns, saying that Mason, after chickening out in the presence of the Kid, came into Fort Sumner "strutting about town, telling how he had met the Kid on the road and had opened fire on him and the Kid had taken to his heels and had been lucky to escape behind a hill. 'I told you what I'd do to that fellow if we ever met,' boasted Barney."

When the Kid later came into town himself, Mason rode for the hills, and the Kid then set the record straight. "I recognized him the minute I saw him, his mantilla and sunbonnet didn't fool me. I would have killed him if his wife hadn't been with him...But with his mantilla and his nice pink sunbonnet, wouldn't he have made a pretty corpse?"

Another humorous anecdote on Mason is given by Colonel Jack Potter involving Mason in a poker game wherein he lost his horse, his saddle and all his money. Undeterred, he sold his coat for two dollars to buy some more chips and kept on going. Inside the coat were delicate documents pertaining to wanted men, among them the

"pastor" who had performed Billy the Kid's funeral. Before this incident was a poker game of a different sort in which he had better luck where Mason had claimed to have won the Chameleon Saloon in Anton Chico (which he lost sometime later in another poker game).

Mason's career as a deputy continued after the Kid's death, and Mason solved the disappearance of one John Berger, who had been thrown from his horse and dragged behind the animal until he was dead outside of Las Vegas, New Mexico. In 1884, Mason rejoined with Garrett for his brief sojourn in Texas to round up a band of rustlers, and after that the two men parted company. This could be due to the fact that Mason became cozy with the new sheriff, John W. Poe. Poe's wife, Sophie, claimed that Mason was the life of their parties and something of a clown. It was also said that Mason began bad-mouthing Garrett shortly after the killing of the Kid because Garrett didn't share any of the reward money with him.

Old-timer Frank Lloyd said that Mason once stole a black calf from Garrett at the Hondo River and then dehorned and sold it back to Pat as a black muley bull. Some actually say Pat was getting the better of Mason in this incident and it was a setup wherein Mason was made to find an "unmarked" calf (which in fact had a small "H" brand between its forelegs) after which Mason was convicted and sent to prison for one year in 1887. Mason was pardoned before the year was even up and moved his family to Alamogordo, and later Portales, where he ran a saloon. In 1908, Mason moved his family to Bakersfield, California, where he would eventually die. Legend states that Mason and his entire family died when the roof of their sod house caved in on them, burying them alive, but more mundane causes (a cerebral hemorrhage) on April 11, 1916, were likely to blame.

3
KILLING (OR NOT KILLING) THE KID: 1881

Oh, yes, Garrett and the Kid were as thick as two peas in a pod.
–Paulita Maxwell, Saga of Billy the Kid

To this day, the debate rages on as to whether Garrett and the Kid were actually friends turned enemies or just amiable acquaintances turned enemies. For what it's worth, after Pat captured the Kid and was transporting him to his hearing in Mesilla, the duo were said to be pleasantly reminiscing about old times. On a train ride, Billy even demonstrated his ability to shove nearly a whole piece of pie into his mouth at once, seemingly not concerned about his impending trial that would surely spell out his doom. As every schoolboy knows, Billy was sentenced to hang in Lincoln but escaped the courthouse jail on April 28, 1881. Garrett was conveniently away collecting lumber for the gallows in White Oaks when Billy escaped, killing his two jailers, supposedly with a gun he found hidden in the privy.

Some people whisper that the famous gun in the privy was left by none other than Pat Garrett himself. While this is pure fiction, some old-timers claimed that Garrett treated Billy quite well during his incarceration. John Meadows said of the Kid and Garrett's presumed friendship that Garrett was nice enough that he put the Kid in longer, more comfortable shackles rather than shorter ones as he should have while incarcerated in Lincoln. Likewise, Meadows claimed Billy told him after his escape that he would never harm a hair on Pat's head.[32]

Meadows also claims that before the Stinking Springs incident, Garrett and the Kid engaged in one final poker game where Garrett politely suggested that Billy disappear and lay low in Mexico for a few years and then he could return. This could have been, as Meadows was regarded as being fairly reliable. It was also the opinion of C.D. Bonney (who also knew Garrett well) that Garrett had the utmost sympathy for the Kid and took into account the fact that he had been orphaned at a young age. It was also rumored that Billy sent Pat a letter stating that if he would just wait for Billy to "finish his business" in Fort Sumner that he would leave New Mexico and the Pecos forever.

In a story related by Rufe Dunnahoo of Roswell in 1931 about how Billy and his gang helped them cross the Pecos, Rufe says that Billy told him to give his regards to "Granny Garrett." This, Dunnahoo says, was Billy's nickname for Pat. Billy calling Pat an old woman pops us in other range tales, too. "The old woman [Garett], will get me one of these days. You'll see. I can shoot a heap quicker than she can—and I don't often miss. But the old woman, she never misses."[33]

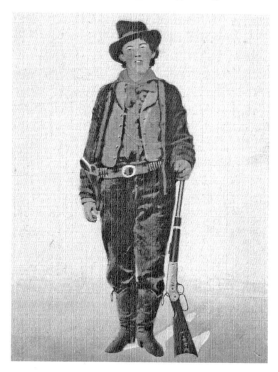

Garrett's greatest nemesis or his best friend, depending on the teller of the tale: the noted desperado Billy the Kid as seen on a vintage postcard. *HSSNM, #103.*

Billy's calling Garrett an "old woman" should clue one in to Billy's true feelings toward Pat, and plenty of comments were made by other old-timers in regard to animosity between the two. Jesus Silva says he once asked Billy if he thought he'd be killed one day. Billy responded, "Yes, I know I'm going to get killed—and I know who's going to do it." Billy is also quoted in Fred Sutton's book *Hands Up!* saying, "Tell Pat to fix things for his funeral; I'm going to drill him first time I see him." Of course, we all know how that turned out.

PAT KILLS THE KID

As with Billy's famed escape from the Lincoln Courthouse, of which there are numerous variations, so too are there a few alterations on his inability to escape the bullet fired from Garrett's gun on July 14, 1881. The basic rundown is that Garrett had finally tracked the Kid to Fort Sumner. The lanky sheriff paid a visit to Pete Maxwell, asleep in bed as it was close to midnight, and began questioning Maxwell as to the Kid's whereabouts. As luck would have it, not two minutes later, in walked the Kid, and Garrett shot him dead.

To start with the basics, and for the sake of accuracy, here is Garrett's official report to the territory:

In view of these reports, I deemed it my duty to go there and ascertain whether there was any truth in them or not, all the time doubting the accuracy; but on Monday, July 11 I left home taking with me John W. Poe and T.L McKinney, men in whose courage and sagacity I relied implicitly, and just below Fort Sumner, on Wednesday, 13th, I remained concealed near the houses until night, and then entered the fort about midnight, and went to Mr. P. Maxwell's room. I found him in bed, and had just commenced talking to him about the object of my visit at such an unusual hour, when a man entered the room in stocking feet, with a pistol in one hand and a knife in the other.

He came and placed his hand on the bed just beside me, and in a low whisper said "Who is it?" and repeated the question he asked of Mr. Maxwell.

I at once recognized the man and knew he was the Kid, and reached behind me for my pistol, feeling almost certain of receiving a ball from him at the moment of doing so, as I felt sure he had now recognized me, but fortunately he drew back from the bed at noticing my movement, and, although he had his pistol pointing at my breast, he delayed to fire and asked in Spanish, "Quien es? Quien es?"

This gave me time to bear on him and the moment I did so I pulled the trigger and he received the death wound, for the ball struck him in the left breast and pierced his heart. He never spoke, but died in a minute. It was my desire to have been able to take him alive, but his coming upon me so suddenly and unexpectedly leads me to believe that he had seen me enter the room, or had been informed by someone of the fact; and that he came there armed with pistol and knife expressly to kill me if he could. Under that impression, I had no alternative but to kill him or suffer death at his hands.

And by Pete Maxwell's own official account:

> *As I was laying down on my bed in my room at about midnight the fourteenth of July, Pat F. Garrett came in my room and he sat on the side of my bed to talk to me. In a little while after Garrett sat down, William Bonney came in, and approached my bed with a pistol in his hand and he asked me, "Who is it? who is it?" And then Pat Garrett fired two shots at William Bonney and the said Bonney fell at one side of my fireplace, and I went out of the room. When I returned 3 or 4 minutes after the shots, the said Bonney was dead.*

Years later, Maxwell told Colonel Jack Potter how he had three opportunities to have been killed that night: first in being between two armed men gunning for one another in a darkened room; next when Billy keeled over dead and the butcher knife in his hand came dangerously close to Maxwell; and lastly, when John W. Poe mistook the retreating Maxwell for Billy and almost shot him before Garrett slapped the gun from his hand.

In his fanciful book *The Authentic Life of Billy the Kid*, Garrett sticks to the versions above for the most part but, of course, neglects to mention the fact that he quickly vacated the room and waited sometime before returning to ascertain the Kid's status. As for the more wild speculations that arose from "street corner philosophers" as they were sometimes called, some claim Pat shot Billy while he was in a drunken sleep. Carl Breihan, a pulp writer for magazines such as *Real West*, alleged that Garrett had cautioned "Maxwell to hold his tongue under the threat of instant death" while he was in the room with him waiting on the Kid. The same article also alleges that once Garret fired the fatal shot, he "jumped through an open window and flattened himself against the wall, his smoking pistol in his hand." Another account also said he was hiding under Maxwell's bed when he took the shot. The July 23, 1881 *Rio Grande Republican* implies Garrett hid behind the head of the bed, "Maxwell took in the situation at a glance and whispered in hardly audible tones, 'That's him.' Pat knew what that meant, but had no time to prepare himself for action so he dropped behind the head of the bed and remained in a crouching position until the outlaw approached the bed on which Maxwell was reclining."

Jim Blakely says in C.L. Sonnichsen's "Neighborhood Talk About Pat Garrett," "One man told me that Garrett entered Maxwell's bedroom that July night in 1881 knowing that Maxwell was lying on one of the two beds in the room. There was a tick on the second bed. When Pat entered the room, he removed the tick and rolled it up, placing it near the head of the bed. Then he

got behind it, facing the open door, through which a full moon was shining." However, this same account also alleges that Pat shot a sheepherder friend of the Kid's and not the genuine article.

The always-sensational *Las Vegas Optic* speculated on July 18, "The belief is that the Kid received intelligence of Pat's presence and was searching for him at the time, or that he had gone to murder Maxwell in his bed."

One of the most interesting variations comes from the son of Albert J. Fountain, Jack, who certainly would've known Garrett as he investigated the murder of Jack's father in the late 1890s. Jack Fountain gave the following account to C.L. Sonnichsen on April 15, 1944:

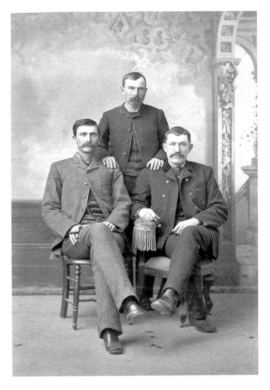

Garrett with deputies James Brent (standing), with him at Stinking Springs, and John W. Poe (sitting, right), with him at Fort Sumner. *HSSNM, #463.*

I rode with Pat Garrett for weeks at a time and on one occasion he told me the straight of Billy's death. "Well, I'll tell you the whole story…The Kid was just in off the range when we arrived and tied our horses [in Ft. Sumner]. *He went to the house of a woman across the street and said, 'I'm hungry, can you cook something for me?' She said, 'Don Pedro has just killed. You go across and cut some meat and I'll fix you a good meal.' He went across, suspecting nothing. The beef was hanging in a little outer room from the vigas. There was a candle and materials for making a light in a niche in the wall. He made a light and held it up while he cut. I was in Pete's room, talking. Billy heard something and asked Pete who was there. Pete said, 'Nobody.' I looked out at a perfect target—Billy lighting himself up with a candle. At first I was just going to wing him. Then I thought if he ever got to his gun it was him or me. My conscience bothers me about it now."*[34]

Billy's pal Yginio Salazer (who most certainly wasn't there for the event) also has his own version. "Billy took his gun and was going to get the blankets off Pedro to see who was with him. When he started to pull the blankets Pat Garrett shot him through the head." Whether Salazar meant to imply that Garrett was hiding under the covers somehow isn't clear, and he elaborated no further.

Francisco Trujillo, another old-timer interviewed under the FWP in the 1930s, said of the shooting, "In the meantime Pat Garrett was negotiating with Pedro Macky [Maxwell] for the deliverance of Billy. When all details were arranged for, Pat left for Bosque Grande secretly. At the ranch house, Pedro hid Pat in a room close beside the one Billy was occupying…he heard voices in the adjoining room. Stepping to the door he partially opened it and thrusting his head in asked Pedro who was with him. Pedro replied that it was only his wife and asked him to come in." The story naturally concludes with Pat shooting Billy, the only other significant alteration being that everyone is too afraid to enter the room again, lest the Kid still be alive. It is not until the next morning when the "cleaning lady" goes inside that the Kid's dead body is discovered.

Though a common story, the "cleaning lady" Deluvina Maxwell herself refuted the claims that she was the first person to find Billy's body. "I did not do it. Pete took a candle and held it around in the window and Pat stood back in the dark where he could see into the room. When they saw that he was dead, they both went in." William Brent heard from his father that Billy was lying face down, and Pat turned him over revealing that the Kid's lips were pulled back exposing his buck teeth.

One bit of hearsay allows that Billy got one shot off at Pat as he fell dying and that Pat jumped out the window to narrowly avoid it. This tale predominately comes from the always-reliable (reliable to be entertaining that is) Federal Writers' Project, specifically an interview with buffalo hunter Buster Degraftenreid, who bought the lumber from the old Pete Maxwell house. He transported the lumber to the Hart Ranch near Melrose, New Mexico, in Curry County. He then used the lumber to build a new house and, because it was easier to do so with the materials, reconstructed the very room in which the Kid was killed.[35] The FWP interviewer, Belle Kilgore, wrote, "One of the window castings has a bullet mark on it and Degraftenreid said that he was told it was made by a bullet the Kid, mortally wounded, fired at Pat Garrett as the sheriff dived out the window close on the heels of Pete Maxwell. Those who were there, however, said the Kid only half drew his guns from their holsters before he died."

A drawing of the Maxwell house by Walter Miles to illustrate Miguel Otero's *The Real Billy the Kid*. *HSSNM, #1861.*

It would seem that whether or not Billy may have fired a shot before he died is one of the bigger mysteries lingering on the fateful shooting. According to some sources, notably James Brent via his son William, Poe and McKinney both claimed to have heard three shots come from Maxwell's bedroom. When Garrett informed them that he only fired two, they inspected the Colt action revolver in the Kid's hands and found that five live shells were in the cylinder, but the hammer was down on an empty as though it had just fired. The trio looked for a bullet mark in the room and found none. William Brent concludes, "It wasn't until years later that a heavy caliber bullet was found embedded in a wall crevice. Was it the Kid's? It will never be known."[36]

However Garrett shot the Kid, it was a tense night for him and his deputies, who feared a counterattack from Billy's many supporters. Allegedly, Pat bided his time by digging the bullet from his second missed shot from the woodwork in Maxwell's room. Fort Sumner sheep rancher Frank Labato remarked that, "had a leader been present that night," a posse may well have gone after Garrett and his men to lynch them.

But for those who like to think Pat and Billy had been good friends, they can hold to the comments of Garrett's deputy there that night, Tip McKinney, be they true or not: "Pat would never speak to me again if I told he cried when he looked at the still face of Billy the Kid."

PAT KILLS THE WRONG MAN (ON PURPOSE OR NOT)

Almost immediately after reports of the Kid's death, the saloon oracles went to work spreading rumors that Billy survived the fatal shot, that Garrett missed or even that the wrong man had been killed and buried in Billy's place. Surprisingly, the sensational *Las Vegas Optic* never got in on these claims and instead delighted readers with accounts of grave robbers pillaging Billy's bones. Talk of Billy's "escape from death" eventually cooled until the early 1900s, when claims began popping up that the Kid was living in Mexico. Garrett once even took the time to refute these claims in a letter. Poor Garrett would likely roll over in his grave if he knew the story circulated by one Homer Overton in 2003.

Overton says that when he was nine years old in 1940, he had a visit with Apolinaria Garrett, the sheriff's widow. At a visit, she showed Overton and a friend one of Garrett's guns. When asked if that was the gun used to kill the Kid, she told them, "Pat did not shoot Billy." Mrs. Garrett then went on to swear the boys to secrecy and also told them that Pat and the Kid were good friends. According to her story, Pat and Billy came across an unconscious Mexican man lying in the streets of Fort Sumner. They both shot the man in the face multiple times so as to make him unrecognizable and then passed his body off as the Kid's. However, considering the great pains Apolinaria went to in order to get the gun that killed the Kid back from the Tom Powers estate in 1934 (see Chapter 9), it's unlikely she believed any stories of Garrett not killing the Kid. Not to mention the fact that Apolinaria had been dead for four years by 1940, unless Overton met with one of Garrett's daughters or daughter-in-laws.

Then there is Elizabeth Garrett, Pat's famed daughter, who while giving piano lessons in Roswell supposedly told a man named Paul Cain that her father didn't kill the Kid as the two were good friends. But again, Miss Garrett herself isn't on record saying this, just the man Cain. Furthermore, Elizabeth was said to be very distraught over reports in the early 1900s that the "art colony crowd" from Santa Fe and Taos planned to erect a statue of the Kid over his grave in Fort Sumner.

Another staunch "Billy believer" was Jose Garcia y Trujillo, who claimed to have known the Kid well. "You think Billy the Keed let himself be shot in the dark like that?" he would often say to interviewers. When one brought him a picture of Pat Garrett, he told the reporter, "I don't want to dispute against you, Señora, but in my mind…I know it is not true. Maybe Pat Garrett, he give Billy the Keed money to go to South America and

write that story [*Authentic Life*] for the looks. Maybe he kill somebody else in that place."

A similar tale was circulated in a 1926 *El Paso Times Herald* that said Garrett offered the Kid $1,000 to leave New Mexico and never return. Generous Billy said he would do it for $25 and rode off for Mexico. Then there are the multitudes of claims that Pat shot a Mexican sheepherder, or Billy Barlow, which shall not be overviewed here as they were exhaustively covered in *Tall Tales and Half Truths of Billy the Kid*.

THE WRONG MAN KILLS THE RIGHT KID

While tales of Garrett faking the Kid's death or shooting the "wrong man" are rampant, there exist very few stories wherein the "wrong man" kills the right Kid. Bill Jones, of the famous Joneses of Seven Rivers (who it should also be noted were sympathetic to the Kid), said, "I knew Pat Garrett. He was the man supposed to have killed the Kid. He got credit for it. I don't think he had guts enough to do it and I think [Deputy John] Poe killed him."[37] Another man who spread this same myth was Tom Story of Phoenix, Arizona. Story claimed Poe shot across Pete Maxwell's body in bed with a cedar-handled .44 to kill the Kid. Eve Ball's notes state, "When they [Poe and Maxwell] heard the Kid coming he [Poe] lay on the opposite side of the bed. Billy struck a match and saw who it was but Poe had him covered. Garrett and Kip McKinney were sitting on the portal." Ball's notes on this tale from Mr. Story also relate another interesting rumor claiming Billy had been killed by a Hispanic version of the Ku Klux Klan known as the "White Caps." Specifically, her notes state, "Mr. Story was at Bosque Grande when this happened. They rode up there [Ft. Sumner] in a mess that morning to clean out the town of the 'White Caps.' The rumor was that White Caps had killed Billy. He and 4 or 5 men went to the funeral. He saw and recognized Billy's body."[38] Carl Breihan also wrote in one of his *Real West* articles that "many believed that Maxwell fired the fatal shot because they knew that Garrett was a poor shot with a pistol."[39] A variation of this tall tale also appeared in another *Real West* article by Lee Miller on Jesse Wayne Brazel that alleged that both Garrett and Maxwell fired at the Kid. It was unknown, according to the article, whose shot got him.

Then there is George Cronyn, who tells a tall tale he heard while working on a ranch in the upper Cimarron Canyon in northwestern New Mexico in

early March 1908, not coincidentally shortly after Garrett was killed. The story appears in *Real West* (the stories therein semi-often anything but real) and was told to him by the ranch foreman Mack Cameron. As Cronyn is working on the ranch, the usually stoic Mack decides to tell the boys a story of the night Billy the Kid was killed and is initially more or less just a recounting of the historical shooting of the Kid with a few minor alterations. Mack concludes his story with the typical bang and the Kid is dead. Only shortly after telling the story, one of the ranch hands arrived to give Mack his mail, which included a recent edition of the paper. Cronyn took note of Mack's shocked expression at the paper's headline, which unbeknownst to Cronyn announced Garrett's assassination.

Later that evening while making biscuits with Cronyn, Mack launched into a very different tale of the night the Kid was killed. It began with Mack making the acquaintance of an unnamed sheriff from Santa Rosa, about fifty miles north of Fort Sumner. On July 11, 1881, this sheriff sent word for Mack to come see him. The impressionable young cowhand, ready for excitement, went, gladly wondering what sort of adventure the sheriff had lined up for him. Arriving in the sheriff's office, Mack was introduced to a man named Jose, whose brother Juan claimed that Billy the Kid was holding his wife hostage in the house of Pete Maxwell, whom he had forced into helping him.[40] Asking if he was to be a part of some sort of rescue operation, the sheriff said that there was a catch: "Jose had found out that Pat Garrett was on his way to the fort, and would be there any day. Now said the sheriff, Pat is no friend of mine, but this whole shooting match belongs to him. He first landed the Kid behind bars and he's responsible for getting him in again, or, if he has to, letting him have it with his six shooter."

In short, Mack was to ride with Juan and Jose back to Fort Sumner to help them rescue Juan's wife. They arrived in town in the early morning hours of July 13 and spent the daylight hours scoping out the house, which the brothers were said to be very familiar with. The two had deduced that the Kid was holed up in an upstairs room where they had seen a candle burning the night before. Their whole scheme depended on the Kid's horse, which they had noticed was kept in a shed next to the house during the day but at night was staked out "about thirty or forty yards from the bedroom door" so that the Kid would have a quick getaway if he needed one. A stealthy Indian friend of theirs was to come by that evening and cut the horse loose. The Kid, who had "ears like a bobcat," would hear the horse and then go outside to hitch him back up, at which point Jose

would go inside to rescue Juan's wife, and Juan himself would lay in wait for the Kid to kill him.

Once the two brothers finished laying out their plan, Mack interceded, saying, "Garrett, I told them, was the law. He had first claim on the Kid, dead or alive. Furthermore, if he found out the Kid had already been finished off, he'd raise bloody hell. Besides, I said the plan they had in mind maybe could be worked out if Garrett agreed so that Juan could still do the job and Garrett get all the credit. Also, there was the wife. The plan had to work just so, or she could get hurt. That shut Juan up, and he agreed to let me try my hand with Garrett."

Toward the evening of July 13, Mack met up with Garrett and his posse. Mack told Garrett that he was here to see Pete Maxwell but was afraid to go near the house, as some of the villagers claimed Billy the Kid was holed up there with a female hostage. A great deal of palavering straight out of an Edgar Rice Burroughs novel goes on for a few paragraphs between Mack and Garrett, of which this reader shall be spared, but the end result is that Garrett agrees to let the two Mexican brothers kill the Kid, for which Garrett will take the credit.

As promised, the Indian man cut the horse loose, and the Kid went out to investigate. As he did, Jose rescued the damsel in distress, and Juan took Pat Garrett's place in history, waiting for the Kid to come sauntering back into his room. Luckily for Juan, the Kid had forgotten his gun, so when he walked back inside, Juan shot him to smithereens. As agreed, Garrett came on the scene later, fired two shots from his own gun and then placed the gun Billy had left on a chest in his right hand. "Soon as I saw everything had gone according to plan, I headed for Santa Rosa, where I reported back to my friend the sheriff. He was mighty pleased the way things turned out."

And wouldn't you know, Mack had the decency to sit on his remarkable tale until the good sheriff Pat Garrett was dead and gone. As the say, dead men tell no tales; others tell 'em for them.

FRIENDS AND FOES OF PAT GARRETT:
SHERIFF JOHN W. POE

Initially one of Garrett's greatest friends, and later a formidable foe in the political arena, was his famous deputy John W. Poe. Like Garrett, Poe started out as a buffalo hunter in Texas before becoming a lawman under Garrett. One of his first missions from Garrett included tracking some stolen livestock all the way to Tombstone, Arizona. Actually, it was Poe's detective skills that tracked Billy the Kid to Fort Sumner the fateful night that Garrett gunned him down. Having never seen the Kid before in his life, Poe initially said to his boss, "Pat, you have shot the wrong man." Actually, it was Poe who almost shot the wrong man when he took aim at a fleeing Pete Maxwell, but nonetheless, Poe's comments would haunt Garrett in later years when people used his naïve statement to cast doubt on whether Pat did indeed shoot Billy.

For several years thereafter, Pat and Poe were good friends. Garrett gladly backed him to become the next sheriff of Lincoln County, and Garrett also named his first born son Dudley Poe. Garrett and Captain J.C. Lea of Roswell also arranged Poe's marriage to wife Sophie. The happy couple resided in the Lincoln County Courthouse, where the new Mrs. Poe was said to despise the bloodstains made by Billy the Kid on the staircase.

John W. Poe (left) sits with E.A. Cahoon inside of the First National Bank in Roswell, of which Poe was president. *HSSNM, #347A.*

Ironically, Poe not only succeeded Garrett as sheriff of Lincoln County but also several years later as the foreman of a ranch in Texas. Poe even followed Garrett's Authentic Life of Billy the Kid *with his own tome,* The Death of Billy the Kid, *published in 1934, long after his death. Eventually, Pat made the mistake of borrowing money from Poe, and things quickly went south between the two. Poe more or less sunk Garrett's chances at being elected sheriff of Chaves County in 1889 when he backed another candidate. After that, one of Mr. Poe's Masonic brothers told him Garrett was threatening to kill him.*

Poe did well for himself in Roswell, beginning the First National Bank there and, in a sense, took over the role of town patriarch when Captain Lea died in 1904. Poe died in 1923, with some whispering he had committed suicide.

4

THE AUTHENTIC LIFE OF PAT GARRETT AFTER KILLING THE KID: 1881-95

If Pat Garrett figured that his troubles with Billy the Kid were over once the young gunman lay cradled in the hard caliche soil of the Fort Sumner graveyard, he was mistaken.
–Leon Metz, Pat Garrett: The Story of a Western Lawman

For a time after the killing of the Kid, Garrett was on top of the world. And just like a celebrity, he spent copious amounts of cash buying drinks for his entourage. Even before the killing, but after the capture of the Kid at Stinking Springs, the *Las Vegas Optic* said of Garrett that he should be "retained as deputy sheriff of Lincoln for 250 years." The July 29, 1881 *Grant County Herald* gave a lengthy praise of Garrett: "The hero of the hour in New Mexico now, the king lion of the Territorial menagerie, is Patsey Garrett, the slayer of the Kid. His name is on everybody's mouth. The papers are full of his exploits and his praises. The very children in the streets stop and honor him with a curious and admiring stare as he passes."

Others speculated as to what great feat Garrett might achieve next. The *Kansas City Journal* suggested he hunt down the James brothers—Frank and Jesse—in Missouri, while the *Albuquerque Daily Journal* wanted him to stick close to home as the territorial U.S. marshal. Even bolder parties suggested that Garrett be sent to Washington, D.C., to guard the assassin of President James A. Garfield, or better yet, kill him as he did the Kid.

Garrett was also lauded with some interesting gifts from the public, one of which was a solid gold sheriff's badge from Albert J. Fountain, and a cane

made of the wood from the Kid's mother's (Katherine Antrim) cabin in Silver City.[41]

The July 23, 1881 *Rio Grande Republican* of the time wrote:

> REPORTS TOWNS MOVED TO ENLARGE REWARD—*It is not to be supposed that the paltry $500 reward offered for the Kid's life or capture could have been of much influence in instigating Sheriff Garrett to the deed of bravery and we are bound to give credit to his conscientious duty as an officer, but yet it is not to be supposed that the reward offered nor any other substantial testimonial of gratitude will come amiss to him.*
>
> *The people certainly owe him much, and nearly every town in the territory is moving to show a cash appreciation of its gratitude. All are equally interested and every place should come up with its mite. Mr. Garrett states that it is his intention to resign his office now that he has the burden of this duty off his hands. His retirement will be a loss to Lincoln County. He has, however, achieved a fame which will be undying, and all will wish him all possible success in whatever new undertaking he may engage.*

Speaking of the $500 reward, Pat would end up having a terrible time collecting it with the acting governor William G. Ritch,[42] who at first refused to pay him the $500 reward for the Kid's death. Theories ranged from the supernatural variety—that it was the Curse of Billy the Kid—to more mundane conspiracy theories that the territorial government doubted the Kid to actually be dead and buried. The *Optic* reported on Garrett's July 19 journey to see the territory about getting paid for a "certain ticklish job." Territorial officials played a stingy game with Garrett, pointing out that Governor Lew Wallace's $500 reward was on the event of the Kid being delivered to the sheriff of Lincoln County when instead the sheriff of Lincoln County had killed the Kid himself (in San Miguel County no less). This silly technicality is what was used to withhold the reward from Garrett. To get the money, Pat had to go to the New Mexico territorial legislature to get help, which ended up costing him around $500 in buying statesmen drinks to get in their good favor. Even the *Las Vegas Optic*, the editor of which reportedly didn't get along with Garrett, felt sorry for the sheriff and began a collection for him from the citizens of Las Vegas in appreciation for killing the Kid. (This is somewhat surprising given that Garrett had just killed their top newsmaker). In "Gritty Garrett's Gift," Russell A. Kistler wrote, "The people of Las Vegas are perhaps as appreciative as any in the world, notwithstanding that they are all meaner than dirt."

Lincoln saloon owner J.A. LaRue, who tried to take a shot at Billy in Lincoln until his wife discouraged him otherwise, W. Scott Moore, owner of the Hot Springs Resort and a purported friend of the Kid and Jesse James, both gave $100, and B.M. Houghton and Co., at whose store the gun that Garrett used to kill the Kid was supposedly purchased, gave $200. Rounding out the pack was First National Bank, which gave $100. When word of this leaked, several private individuals, among them James Dolan, sent Garrett money that helped mostly to pay his gambling debts he racked up in the capital.

GARRETT VERSUS BILLY'S BROTHER

Though Garrett received mostly praise from the newspapers, one paper in San Francisco said that Garrett should be tried for murder. Eventually, talk began to turn that Garrett had shot the Kid unfairly, which frustrated poor Garrett something fierce. His friend C.D. Bonney said of the killing, "They talk as if when Billy entered Maxwell's bedroom while Garrett was sitting on the edge of the bed talking to Pete, Garrett should have tapped the Kid on the wrist and said, 'Come along, Billy Boy; there is a scaffold down in Lincoln town, and we must hurry along. Otherwise we may be late for your hanging.'"[43]

Around this time, rumors began spreading that members of Billy's gang planned to avenge him by killing Garrett.[44] Yet another rumor floated that the Kid's long estranged brother, Joe Antrim, wanted revenge. Conflicting stories state that Joe was either the Kid's younger brother or his elder, but he certainly looked older than the Kid. No angel himself, Joe was rumored to be a rough character who smoked opium in Silver City's version of Chinatown. Supposedly, the last time Joe had even seen his brother was when Billy was fleeing through Silver City after killing Windy Cahill in Arizona back in 1877. Joe Antrim was living in Trinidad, Colorado, as a professional gambler when news of his brother's death reached him. A sensational account in the *Daily New Mexican* on December 7, 1881, claimed that Joe was "known as a hard case" and that he was "thirsting after Pat Garrett's blood."[45]

Conflicting sources say Garrett met Joe Antrim in either Trinidad, Colorado, or Albuquerque, New Mexico, at the Armijo House.[46] The hotel was owned and operated by none other than W. Scott Moore, who owned the Hot Springs Resort in Las Vegas where Jesse James had once met Billy the Kid while a guest there. Garrett had checked in to the Armijo House on August 2, 1882, and was playing pool when Joe walked into the room.

Reportedly, things grew tense and silent, and onlookers aware of the two men's reputations slowly made for the exits. Reporters were disappointed when the two men merely began conversing quietly. The talk was said to last for several hours, and when it was over both men stood and shook hands. After this, both men made remarks that there was no ill will over the killing of the Kid, and Antrim understood Garrett's difficult position in the matter. Garrett told the *Albuquerque Evening Review*, "We parted the best of friends."[47] Conspiracy theorists would probably like to believe that perhaps Garrett told him he didn't kill the Kid, but in real life, Joe and his brother weren't close, and he later denied reports that he had ever thirsted after Pat Garrett's blood. Antrim died on November 25, 1930, with only $1.25 to his name.

THE AUTHENTIC SCANDAL OF GARRETT AND UPSON'S *AUTHENTIC LIFE*

Today, it is common practice for anyone who has had their "fifteen minutes of fame" to write a book about it. Back in Garrett's day, it was something of a novelty. In this regard, Garrett was indeed a trendsetter. And he was keenly aware of the success of several dime novels being published on the Kid, all of them more or less fictitious. Charles W. Greene, editor of the *Santa Fe New Mexican*, approached Garrett about writing a book on his capture and killing of the Kid.

As Garrett didn't relish the thought of writing a book, he turned to a former journalist he had met in Roswell, Ash Upson. The result was the sensationally titled and composed *An Authentic Life of Billy the Kid, the Noted Desperado of the Southwest, Whose Deeds of Daring and Blood Made His Name a Terror in New Mexico, Arizona and Northern Mexico* by Pat F. Garrett, sheriff of Lincoln County at whose hands he was killed. As Garrett was unaware of the Kid's early life, he simply let Upson's imagination go to work, which concocted a vivid tale in which Billy commits his first kill by stabbing a man who insulted his mother. Another of the bigger myths in the book's 137 pages stated that William Bonney was born in New York on November 23, 1859, when, not coincidentally, November 23, 1828, was really Upson's birthday. From then on, most of Upson's fabrications were reported as facts for the next seventy years.

The book, due to the publisher's limited resources, was an unmitigated failure despite the popularity of Billy the Kid dime novels. The *Las Vegas*

The cover of the eleventh edition of Garrett and Upson's initially ill-received *Authentic Life of Billy the Kid*. *Author's collection.*

Daily Optic even made the comment, "Pat Garrett is sick at Roswell. Probably the 'Life of Billy the Kid' in print as executed by the *New Mexican* gave him gangrene of the bowels." However, the *Optic* was never fond of Garrett taking up a notion to write his own book anyway and publicly criticized him, as did the *Mora Pioneer*, which wrote:

> *Every citizen should purchase at least ten copies of the work, to assist the writer. Mr. Garrett, as sheriff, took the life of a noted desperado, and the people have rewarded him. This would have satisfied some men. We can see no pressing necessity for the work he is to have printed, and can only look on it as the means of reaping a further harvest from a lucky shot. By all means let people buy the book, and thus encourage literature and the performance of duties by public officers.*

Garrett responded, "Whose business is it if I choose to publish a hundred books, and make money out of all of them, though I were as rich as the Harper Brothers?"

Upson said:

> *It has been bungled in the publication. The Santa Fe publishers took five months to do a month's job and then made a poor one. Pat F. Garrett, who killed the Kid, and whose name appears as the author of this work (although I wrote every word of it) as it would make it sell, insisted on taking it to Santa Fe, and was swindled badly in his contract. I live with Garrett and have since last August. His contract said they were to settle on the book every sixty days…The publisher does not know how to put a book on the market.*

Upson hit the nail on the head, as the relatively small publisher was in no way prepared to market a book across the country, and Garrett's royalty percentage was quite small.

Someone who did know how to put a book on the market was Charles Siringo, the "Cowboy Detective" who visited the Roswell-Lincoln area semi-frequently, and had a very small role in the tracking of Billy the Kid. Three years later came his book *A Texas Cowboy*, and his chapter on Billy the Kid made the book a huge bestseller of its time, with Siringo claiming that it sold one million copies. And Siringo got almost all of his information from Upson and Garrett's book and ended up making a killing on it. Ironically, years later, when *The Saga of Billy the Kid* was published, Siringo sued Walter Noble

Burns for lifting information from him, when in fact most of Siringo's info came from Upson. Likewise, *Authentic Life* has now been reprinted multiple times and is still in print to this day and sells quite well. It was yet another example of Garrett's sour luck.

PAT GETS POLITICAL

Choosing not to run for sheriff of Lincoln County for a second term in the 1882 election, Garrett instead turned his attention toward being a councilman, for which he successfully secured a nomination against his former political backers John Miller and David Easton. The two men slandered Garrett in the press, claiming that he was illiterate and that "the newspaper attention he received over killing the Kid had 'upset his brain.'" A scandalous letter published in the *Republican* so enraged Garrett that he tracked down the author and pistol whipped him over the head until he fell unconscious. No charges were ever filed against Garrett, and the bitter race continued with much slander. Coincidentally, one candidate was even accused of grave robbing. This was during a time in which stories of the theft

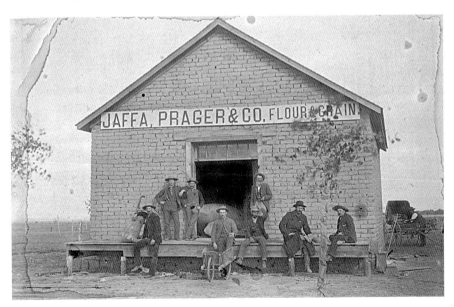

Garrett, second from left, sits on the porch of Jaffa, Prager and Co. in Roswell shortly after killing the Kid. *HSSNM, #2914.*

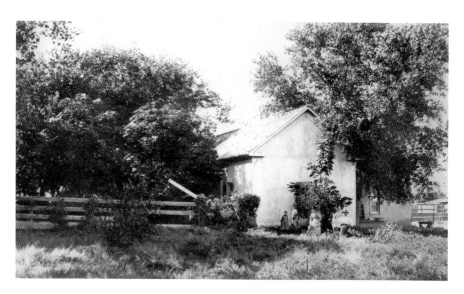

Garrett; his wife, Apolinaria; and three of their children recline in front of their Roswell home. *HSSNM, #1887.*

of Billy's bones were common, thanks to sensational newspaper reports. In the end, Garrett lost, though he did occasionally serve as a county delegate for the next few years. As for the new sheriff of Lincoln County, Garrett's old deputy John W. Poe was elected.

STINKING SPRINGS SEQUEL IN TEXAS

In the mid-1880s, Garrett bided most of his time on a horse ranch he operated at Eagle Creek, using the brand P A T. But he soon became restless and longed to get back on the trail looking for outlaws. Lucky for him, at the suggestion of one of his former deputies, Sheriff Jim East, Garrett was appointed by the governor of Texas to head a group of Texas Rangers charged with breaking up a cattle-rustling ring. Pat traveled to Tascosa, a place his old friend the Kid used to haunt, and organized a posse to go after the rustlers. Some historians are overly, and perhaps ignorantly, harsh on this brief tenure. Pulp-article author Joe Heflin Smith, for instance, claims that outlaws among the Canadian River made fun of Garrett and called him a "has-been." The truth is Garrett wasn't unsuccessful at his new job.

Garrett's main adventure in this episode ended up remarkably like the one he had endured at Stinking Springs in the winter of 1880. Now the winter of 1885, Garrett found himself cornering a small group of outlaws in a small rock house at Red River Springs accompanied yet again by Barney Mason and Jim East, both formerly present in Garrett's Stinking Springs posse. To top it all off, the incident occurred during a snowstorm. To quote the irreplaceable Leon Metz, "A theory of Garrett's, one that he successfully practiced twice on Billy the Kid, was that a storm offered the best time to hunt a badman." This standoff was slightly more peaceful than Stinking Springs, with nine men not wanted for rustling by Garrett allowed to retreat from the house. And finally, after negotiating with the wanted men, they agreed to surrender. Again, coffee was made, bacon fried and the hungry prisoners fed. Once delivered to the jail in Tascosa, the men were slipped a file by a sympathizer, and soon their chains were cut and the outlaws footloose and fancy free. They were never recaptured, nor did Pat bother to chase after them a second time. It was his feeling that he had been hired to kill the rustlers rather than capture them.

After that, Garrett became a manager of a cattle theft detective agency in Tascosa, which didn't last terribly long, and he later became manager of Captain Brandon Kirby's ranch in the Tascosa area. This, too, didn't last long, and Garrett was succeeded, ironically, by John W. Poe.

PAT GARRETT THE SECOND

One of the better known pioneers in the town of Roswell was Frank Blashek, who had many children and operated Blashek's Mill. In 1885 was born one of several sons, whom the couple named Pat Garrett Blashek. Eventually, this Pat Garrett the second would become the only survivor of the family after all his siblings, none of whom had married, died. Afraid to stay at the mill on his own, Pat instead roamed the town as one of Roswell's more notable eccentrics. He was said to change clothes only twice a year, never bathed and had two-inch-long thumbnails. The only thing he had in common with his namesake was a penchant for gambling and drinking, on which he wasted his inheritance. Often seen riding his bicycle all over town, Pat Garrett Blashek passed away on March 13, 1973.

PAT IRRIGATES THE PECOS

One of the greatest disappointments of Pat's life was his failed scheme to irrigate the Pecos Valley.[48] Actually, to say it failed isn't accurate. It did succeed; Garrett just never received the proper credit for it.

While living in Roswell on an 1,800-acre ranch with his wife and children, which now numbered four total, Garrett purchased a one-third interest in the Texas Irrigation Ditch Company in early 1887.[49] It soon changed its name to the Holloman Garrett Ditch Company and later dissolved. Garrett was undeterred and hatched a new plan to dam the Rio Hondo at a certain point, so eventually the water would flume out across the farmland. To accomplish this, Pat joined up with Charles B. Eddy, a wealthy land developer from the Pecos Valley.

Ash Upson acted as publicist and wrote several articles promoting the project. It seemed irresistible for Upson not to also poke fun at his friend's height and long legs when he wrote in one of them, "While wandering around looking at the situation, and studying over this question, he accidentally stepped across the Hondo where it was not more than twenty feet wide."

As misfortune would have it, Pat's former publisher, Charles Greene, was in Roswell gathering information for a new book that ultimately was never produced. Instead, Pat told him about his irrigation plan, which Greene latched onto. On July 18, 1885, the trio formed the Pecos Valley Irrigation and Investment Company with Greene as general manager. Garrett and Eddy meanwhile traveled all the way to Chicago and other eastern locales to find investors over the next three years.

Ultimately, Garrett succeeded in forming the Northern Canal in Roswell, which was completed in 1890 and stretched for forty miles. As the biggest thing to happen in the Pecos Valley since the killing of the Kid, the project drew a great deal of interest and, eventually, financial strain, forcing Eddy to seek more backers. He went to Colorado Springs to approach the famous cigar manufacturer Robert Weems Tansill about investing. Instead, Eddy ended up partnering with railroad magnate J.J. Hagerman, who bailed the company out and reorganized it as the Pecos Valley Irrigation and Improvement Company. The Northern Canal was also renamed the Hagerman Canal. Though he got along splendidly with Eddy, Hagerman considered Garrett beneath him and eventually edged him out of the company altogether. Once again broke, Pat returned to Roswell to cook up a new scheme while Hagerman's company became the

success Pat had hoped to be his. New settlers descended upon the Pecos Valley, and several new towns such as Dexter, Lake Arthur and Hagerman sprang up. The new boss in Roswell, Hagerman even purchased John Chisum's old South Spring Ranch and moved there permanently. One

A large irrigation ditch in Roswell that was a part of the Pecos Valley Irrigation and Improvement Company. *HSSNM, #1814.*

The Garrett home in Roswell in later years, long after the family had left. *HSSNM, #1363.*

Pat Garret Dam on Hondo River

The history of "Pat Garrett Dam" along the Hondo is for the most part unknown—perhaps it is a mislabeled photo? *HSSNM, #1366.*

of Garrett's biographers, Richard O'Connor, at least had the decency to write, "[Garrett's] real monument was not the gravestone of Billy the Kid but the fruitful Pecos Valley as it stands today."

Pushed out of the company he helped to create, Pat's new scheme—and he always had one up his sleeve—was to be elected sheriff of a new county, but he'd have to create it first. As Roswell had longed to become the seat of its own county, separate from Lincoln, Garrett journeyed with Captain J.C. Lea and Charles Eddy to the territorial council and house in Santa Fe to propose just such a measure. Though met with opposition by James J. Dolan of all people, two new counties were carved out of Lincoln, with Roswell the seat of Chaves County and Eddy (eventually renamed Carlsbad) the seat of Eddy County on February 25, 1889. For once, Pat had succeeded. He did not however, succeed in becoming sheriff of Chaves County. His old deputy John W. Poe was already backing and grooming a new candidate, Campbell Fountain, who beat Garrett in the election.[50] Highly insulted, Garrett packed up his family, and even old Ash Upson, and moved to Uvalde, Texas.[51]

In Uvalde, Garrett planned to implant a new irrigation scheme, and Upson would even write a follow-up of sorts to *Authentic Life* on the Lincoln County War, or so they planned.[52] Neither of these schemes played out, and Pat spent most of his time racing and betting on horses.

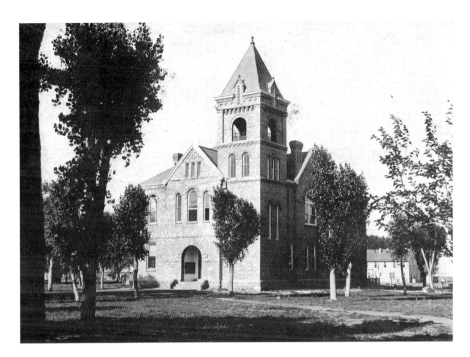

The Chaves County Courthouse circa 1890. *HSSNM, #747A.*

Apparently, the Curse of Billy the Kid wasn't applicable in Texas though, for Garret was not only happy in Uvalde but also successful in his gambling for once. Breeding and racing quarter horses, Pat actually appeared to be making money. Garrett also made friends with a future vice president of United States, John Nance Garner, whom Garrett even named some of his race horses after. In 1894, the duo promoted some races in Rock Springs, Texas, in which Garrett's horse Minnie beat out the local champion Gulliver. Even Garrett's advice to others when it came to horse racing was said to be entirely sound. But like all good things, Garrett's time in Uvalde would come to an end. And it would all be thanks to the siren's call of New Mexico Territory.

FRIENDS AND FOES OF PAT GARRETT: ASH UPSON

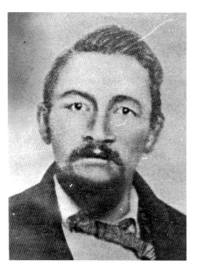

Marshal Ashton Upson as he appeared during the days of the Lincoln County War. *HSSNM, #4008.*

As comical, colorful character the Old West ever had was Marshal Ashton Upson, born on November 23, 1828, in Connecticut. A journalist by trade, in 1850, Upson began wandering with whiskey in hand across the West, notably New Mexico, where he established the Albuquerque Press *in 1867. During his wanderings, he had even stayed at the boardinghouse run by Katherine Antrim and met young Henry Antrim, soon to be alias Billy the Kid. Upson eventually drifted to Roswell, where he fell in with a fellow gambler and boozer, Van C. Smith. The town of Roswell was the site of nonstop card games, horse races and even cock fights. Poor Pat Garrett would've loved the town before J. C. Lea arrived and cleaned it up. For that matter, Upson also butted heads with the morally conservative Captain Lea during his time as postmaster and justice of the peace there. Upson was said to have resigned once Lea found out Upson had drunk an entire stock of the alcohol-laced cure-all Hostetter's Bitters. Though it is not known how, Garrett and Upson eventually befriended each other. Upson was eventually hired on by Garrett as his bookkeeper at the ranch and publicist of sorts and even moved onto the Garrett homestead. Not unlike a "crazy uncle" character on a sitcom, Ash Upson came along with the family when they moved to Uvalde in 1890. Leon Metz relates the relationship between Garrett and Upson in jovial style. "At his side tagged the ever-faithful, always crusty, heavy drinking, profane Ash Upson. Seemingly he lived out of a liquor bottle, and his bouts with the demons were a continuing source of embarrassment to the Garrett family."*

A particularly comic episode occurred when Upson, along with Charles Siringo, was supposed to pick Garrett up from Pecos Station in a buggy once Garrett got off the train. When the train was late, Upson and Siringo got bored and meandered up to Toyah to go drink and gamble. When Pat arrived and found no one waiting for him, he angrily telegraphed Upson to come and get him; Upson responded that he couldn't because he now "owed every man in town." Garrett responded that he would leave

him behind if he didn't come soon, and Upson telegraphed back, "Go to hic, hell, damn you." Pat traveled to Toyah, paid Upson's saloon bills and took him home.

A well-liked if controversial figure, Roswell newspapers were reporting on Upson's death even before it had happened when Ash failed to return from a Connecticut visit to see his dying mother. The paper stated, "Since that time nothing has been heard of him, and it is feared that he now lies in an unknown grave, in a strange land and that his fate may never be known." Ash would have surely been pleased at the sensational attention he received in the paper in 1893, and Upson indeed made it back to Uvalde, where he passed away on the Garrett ranch on October 6, 1894.

A sketch made of Ash Upson as he appeared to his niece. *HSSNM, #1564.*

5

THE SHERIFF OF DONA ANA COUNTY AND THE SEARCH FOR ALBERT FOUNTAIN'S BONES: 1896-1900

If Colonel A.J. Fountain had not lost his life in 1896, Garrett might have lived out his days in Texas and slept under the Uvalde live oaks.
−C.L. Sonnichsen, Pat Garrett's Last Ride

Like all great action heroes, Pat Garrett was not the central protagonist of only one adventure—in this case, the tracking and killing of Billy the Kid—but in 1896 starred in a "sequel." And if ever there were a worthy follow-up to the Lincoln County War in sheer political conniving and intrigue, if not violence, it was the mysterious death of Albert Jennings Fountain and his young son Henry. Not unlike the plot of the perennial action movie sequel, a retired, down-on-his-luck Garrett in need of redemption is called back into action for "one last job." And of course, there were formidable villains in this cowboy drama as well. Taking the place of Billy the Kid was Oliver Lee, a handsome young charmer suspected of the murders. And yet again out to get the daring desperado was the Santa Fe Ring. Only in an interesting twist emerged a new political villain, Albert B. Fall, who was so conniving that by contrast Thomas Catron, the Santa Fe Ring boss, appeared to be on the side of the "good guys." Once again, Garrett was at the center of it all, and like the last episode, he would not exactly receive a happy ending.

The scandal began with two men in Dona Ana County. Leader of the Republican Party, Albert Jennings Fountain was the sworn enemy of the leader of the Democratic Party, Albert Bacon Fall. Fountain had

just secured indictments for seventeen men accused of cattle rustling from the New Mexico Stock Association. Among them were Bill McNew, Jim Gililland and Oliver Lee, a friend of Fall's. After serving the indictments in Lincoln, it was time for Fountain, who had been receiving death threats, to travel home across the White Sands. Three days later, Fountain's eldest sons went out looking for their father and brother. Only an empty buckboard was found, minus the bodies, and later, as the search intensified, a puddle of blood was discovered by Eugene Van Patten. Around the buckboard were the tracks of three horsemen, and it appeared that the tracks led straight to Oliver Lee's Dog Canyon Ranch—though eventually cattle from this same ranch were herded across these tracks before anything official could be deduced. As such, the three primary suspects in this mystery became Lee, Gililland and McNew.

It was probably no coincidence that the local press, owned by Fall, began reporting stories that Fountain had merely absconded with his favorite son, Henry, to go back east to Chicago and was not dead. He was also "seen" in California and Mexico (the latter sighting even prompted one man to go on a year-and-a-half-long wild goose chase in Mexico looking for them). The primary suspects didn't even bother to go on the lam, and rather than become suspicious, the public of southeast New Mexico instead became sympathetic toward them. This did not bode well for Garrett's investigation, which had yet to begin.

Garrett was still living peacefully in Uvalde at the time of the disappearances and read about them in the papers. He was delighted to hear that many New Mexicans felt that he was the prime candidate to bring the killers to justice. If he could track down Billy the Kid to a darkened room in Fort Sumner, then surely he could catch the Fountain killers on the bright White Sands. The stakes were certainly high, as some even said the fate of New Mexico's statehood was on the line if the murders couldn't be solved.

New Mexico officially came calling in the form of Governor William T. "Poker Bill" Thornton,[53] who tracked down Garrett in El Paso, where he planned to attend a heavyweight championship fight between Bob Fitzsimmons and Peter Maher that was eventually cancelled. Garrett accepted his offer to become a chief deputy sheriff with jurisdiction in the Fountain case, with intentions of running for sheriff during elections. Some say Garrett took the job to prove that his killing of the Kid wasn't just a fluke, while others said he did it to pay off his seemingly perennial gambling debts. If it was to prove himself still worthy of a badge, Garrett need not have worried; of his peers still living, Bat Masterson was now a referee in prize

Footprints in the White Sands in this undated photograph by Paul Larkham. *HSSNM, Larkham Album 3.*

The mysterious White Sands, where Albert Fountain and his son disappeared forever. *HSSNM, Larkham Album 3.*

fight matches, and Wyatt Earp was a mining promoter. Still, Garrett looked to top off his career with something magnificent.

Garrett and his family moved to Las Cruces to take up the case, and Garrett focused all of his efforts on capturing Oliver Lee.

OLIVER LEE AND THE BATTLE OF WILDY WELL

One of the more notable scenes to play out in the Garrett-Lee drama was a marathon seventy-hour stud poker game. In the backroom of Tobe Tipton's saloon in Tularosa, Garrett came across none other than Oliver Lee, A.B. Fall, Jeff Sanders, Tipton and a future governor, George Curry, playing poker. Tipton offered Garrett a seat, and too brazen to decline, Garrett took it and asked to be dealt in with his enemies. For the next day and beyond, the sextet sat in tension verbally sparing with one another, fencing around the real topic at hand of which no one spoke: the Fountain killing.

Curry, perhaps bored, decided to stoke the fire and let loose the remark, "I've been hearing that the Dona Ana grand jury is going to indict somebody in this crowd for doing away with the Fountains. My guess is that somebody in this bunch may want to hire a lawyer before long, and I have an idea that the lawyer he might be going to hire is sitting at this table."

Everything was dead silent. Years later, in retrospect Tipton remarked, "There was more dynamite gathered around that poker table than could be found in any other room in New Mexico. There we were, sitting around a powder keg, and Curry deliberately struck a match." The explosive situation diffused peacefully though.

Lee started, "Mr. Sheriff, if you wish to serve any papers on me at any time, I will be here or at the ranch."

Garrett finished, "Alright, Mr. Lee if any papers are to be served on you, I will mail them to you or send them to George Curry for serving."[54] That seemed to ease the tension, and with the matter settled, Garrett stood up and excused himself rather than let the situation escalate into Pat Garrett's own personal version of the Shootout at the OK Corral.

The fireworks would erupt later when Garrett went to collect Lee and Gililland at Wildy Well on July 12, 1898. Using the same seemingly lazy tactic he used on the Kid, Garrett lulled the men into a false sense of security and finally came after them a full three months after having served the indictments on them. The fight at Wildy Well was destined to become a battle nearly as famous as Stinking Springs. However, it is mainly famous because Garrett lost the fight. This was made all the more embarrassing by the fact that Garrett's posse outnumbered Lee's men, which consisted of Gililland and a friend, McVey. There was also a neutral party in the house, a cowboy named Madison and his wife, who were accosted by Deputy Espalin thinking they were Lee and Gililland.[55] Instead, he embarrassed himself, and McVey, also in the room, let out a warning to Lee and Gililland, who were

actually sleeping on the roof. To fire at the men, Garrett climbed on the roof of a nearby shed. Mrs. Madison, who was later interviewed under the FWP, gave this account:

> *Pat Garrett…caught sight of the fugitives on top of our house and opened fire. The charge was returned with a volley from the guns on the roof, and we could hear the bullets falling like hail all around us. Just as I grabbed my son and pulled him down beside me on the floor, a bullet crashed through the window, whistled through the room, and buried itself in the wall above the bed. My husband told me that the sheriff went up to bring Lee and his men down, but just as he reached the top of the ladder one of his deputies who had climed up an [sic] the other side, was shot and rolled off the roof into a wagon just outside the kitchen door.*

The man who had been shot was Deputy Kent Kearney, who would later die from the wound. Lee and Gililland got the best of the other men, too. Garrett was grazed in the ribs, and another bullet nearly got him in the head. One of Garrett's deputies under a water tank got soaked when Lee took aim at it in a rather ingenious maneuver. A parlay began, and it was decided the outlaws had gotten the best of them. Garrett and Espalin, who was hobbling about painfully due to stickers he received when he took his boots off to sneak up on the house, were allowed to retreat.

Mrs. Madison claims Garrett yelled, "We'll be back to get you fellows by eleven."

"Be sure ye don't get here before that time, or we might get ye first." Lee was said to reply.

Later, the *Independent Democrat*, controlled by Fall, wrote of the incident, "If Lee had the opportunity he could have killed Garrett and would have automatically had a perfect alibi for murder in self-defense."[56]

Likewise, old-timer Jim Blakely revises the adventure in his own account, and it is Garrett who bears the brunt of humiliation, not just his deputies. In his account, it is Pat who is soaked from the water tank and "was about to drown," and it is also Pat who treks off in humiliation in his stocking feet getting stickers all the way. Blakely said, "For some reason Pat had removed his boots before the fracas started…without his boots and unwilling to take orders before his possemen, Pat told two of his deputies to go get the team."

Blakely goes on to say, "Lee told Pat, 'I told you to go, and I mean it!' Pat went. He hobbled across the rocks and the cactus in his stocking feet and brought the horses back."

Many people whispered that Garrett never intended to arrest Lee but to "murder" him as he did Billy the Kid. One of these men was Dee Harkey, who claimed to have met Garrett and his posse on the road to Wildy Well. Harkey says Garrett asked him to come along to arrest Lee, and Harkey told Garrett, "You are not going there to arrest Oliver Lee. You are going there to kill him!" Harkey says Garrett lightly concurred with this statement, replying, "Well, in my opinion, the best way to deal with a cold-blooded killer is to kill him and be done with it."[57]

THE HUNT FOR OLIVER LEE

In accordance with rumors that Garrett intended to kill him, Lee refused to turn himself over to Garrett. Fall, crafty as ever, had a solution: to create a brand new county with the murder site in its jurisdiction. However, Lee and Gililland remained in hiding for nearly a year before this scheme came to fruition, partly due to the fact that their defender Albert B. Fall had made it a hobby of participating in the fighting of the Spanish-American War.

The next year was a comical farce not unlike a *Pink Panther* film, with poor Garrett in the role of Peter Sellers's Inspector Clouseau on the trail of Lee and Gililland, who had grown beards that apparently rendered them invisible to Garrett on several occasions. One story went that Garrett passed Lee, the very object of his obsession, along the roadside without granting him a second look. Another day, Garrett spent hours, possibly the entire day, guarding a bridge that he assumed the duo would attempt to cross. He was right, only the duo forded the river lower down, much to their amusement, knowing they had pulled yet another one over on the old man.

Lee wrote letters to the editor of the *Independent Democrat* at his pal Gene Rhodes's ranch in the San Andres and even managed to draw the sympathy of the famous Judge Roy Bean's elder brother Samuel G. Bean, who concurred that Garrett would probably kill Lee the same as Billy the Kid. Lee even found the time to marry Winnie Rhode, sister-in-law of Garrett's nemesis neighbor, W.W. Cox, whom he would enter into a feud with years later.

Meanwhile, in the words of Leon Metz, "Street corner philosophers argued heatedly over who had the more raw courage and who would win if Garrett and Lee ever met on even terms."[58]

PAT GARRETT-ACTION HERO!

Pat Garrett's investigation into the Fountain murders was quasi-adapted into the 1948 motion picture **Four Faces West,** *which is itself adapted from Eugen Manlove Rhodes's novel* **Paso Por Aqui,** *itself lightly inspired by the Fountain case. This film was followed by two other solo Garrett adventures, set either before he knew the Kid or after he killed him. In* **Outcasts of the Trail** *(1949), Monte Hale portrays Garrett with a southern accent, which is the film's only historical accuracy, the rest being pure fiction. Garrett's last solo ride occurred in 1958's* **Badman's Country,** *which has George Montgomery as Garrett. The story features an epic mash-up wherein Garrett teams with Buffalo Bill Cody, Bat Masterson and Wyatt Earp to chase down Butch Cassidy and the Sundance Kid. These are the only three films to focus solely on Garrett compared to the one hundred or so on-screen adventures of Billy the Kid.*

ANTI-CLIMAX AT HILLSBORO

Eventually, the conniving Fall's plan to create a whole new county to protect Lee came to fruition. Initially, Fall found himself opposed by both his nemeses Tom Catron and Governor Otero, who although he disliked Catron disliked Fall more. That all changed when Fall offered to name the new county Otero and the governor changed his mind. Otero County (though it should have been called Lee County since that's who the county was really created for) was carved out of Dona Ana on January 30, 1899, with George Curry as its new sheriff. Lee's "surrender" was then negotiated with the new sheriff, firmly entrenched in Fall's pocket.

Lee and Gililland in disguise then boarded a train headed for Las Cruces under the custody of Gene Rhodes. By sheer coincidence, Garrett was also on the same train, transporting a prisoner. Though it's debatable whether Garrett knew they were somewhere on the train, he was reported to be acting suspicious, as though on the lookout for someone. At one point, he walked into the same car in which the disguised outlaws sat, stepped right in front of Lee (sporting a heavy beard and pretending to read a book) and stared for a long while out the window. Incredibly, Garrett left, not bothering or acknowledging the men, leaving everyone, historians included, to wonder whether Garrett was playing a game with Lee, too chicken to arrest him or simply oblivious.

May D. Rhodes wrote of the incident for *New Mexico Magazine* in 1947. When Rhodes saw Garrett walk into his train car, he thought to himself, "Now we will have some plain and fancy shooting."

May Rhodes wrote:

> *Garrett walked down the aisle and, reaching Gene's seat, he stopped and spoke to him. Then he put his foot up on the end of seat and made some remark. Gene later said that was one time he did not want to visit with Pat Garrett. Garrett observed the men* [Lee and Gililland] *in the next seat closely. He evidently decided they were what they looked to be—prospectors. He made another remark to Gene. Gene recalled later that his very finger tips tingled. He turned the page of his book although he had not read the two proceeding pages. Pat Garrett moved on down the aisle and through the door that he had just entered. Gene heaved a sigh of relief, and the others must have felt the same.*

The climactic—or, rather, anti-climactic—final battle took place in the courtroom of Hillsboro, capital of Sierra County (there was a change in venue that made Otero County unavailable), a good three years after the murders, in May 1899. The town became a media circus, and newspapers across the country reported on the sensational trial, which in fact was no longer about Fountain and Lee so much as it was a battle of wills between the Santa Fe Ring and Fall. The ring feared that if Fall won the trial his rise to power would continue, perhaps even taking the governor's seat.

Conveniently, a few star witnesses failed to appear, and the ones who did were torn to pieces by Fall, who confused the jury and the witnesses alike. Garrett was the only one who took the stand that Fall didn't succeed in humiliating. When Fall asked Garrett why he didn't seek a bench warrant sooner, Garrett coolly quipped, "You had too much control of the courts." The courthouse responded in laughter. Despite Garrett's best efforts, jurors found Lee, McNew and Gililland not guilty. As for Fall, he profited little, if any, from the trial. Instead, his victory was a political one, dethroning Thomas Catron as the most influential man in New Mexico.

Once, while touring Roswell in a wagon with author Emmerson Hough, an antelope darted in front of Garrett's buggy. Pat grabbed his rifle only to have it misfire while the animal was in his sights. Garrett cussed and remarked that the same thing once happened when he had Oliver Lee in his sights. Garrett enjoyed recycling this joke, and during a walk with C.D. Bonney in Acme, New Mexico, the party took sight of a coyote. Garrett raised his Winchester to fire, only it failed to do so. Ironically, he said, "I have never told this before, but this is the

The Organ Mountains near Las Cruces, New Mexico, near much of where the Garrett-Lee drama took place. *HSSNM, Larkham Album 3.*

same gun and this is exactly what happened when I had Oliver Lee in my sights that morning in the fight at Wildy Well." Garrett's comments are somewhat ironic since Lee always said he would never turn himself over to Garrett for fear that he would shoot him on sight. Perhaps he was right.

BRAWL AT THE COX RANCH AND OTHER ADVENTURES

Of course, Garrett didn't spend his entire tenure in Dona Ana County looking for Fountain and his murderers. There were other cases, such as in 1896, when Garrett investigated the possibility of Chinese immigrants being smuggled across the Mexican border.

An incident that would end up haunting Garrett until the day of his death was the killing of an escaped convict on the W.W. Cox ranch in October 1899. Jose Espalin, Garrett's current and past deputy from the Wildy Well shootout, shot the convict and begat a feud between Garrett, Cox and Print Rhode.

The story begins with Garrett trailing a fugitive from an Oklahoma penitentiary at the request of the sheriff from that territory. The fugitive, Norman Newman, alias "Reed," had drifted to Cox's ranch and had been employed to help the pregnant Mrs. Cox in the kitchen. When Garrett barged in on Newman he was washing dishes with Mrs. Cox sitting nearby. Reed

attacked Garrett, and an intense brawl erupted. The commotion excited, of all things, A.B. Fall's pet bulldog Old Booze which lived on the ranch, and he too joined the ruckus. When Reed finally broke free from the mêlée, he ran for the meat house but was stopped by a bullet from Espalin. The gunshot frightened away Old Booze and also Mrs. Cox, who suffered a miscarriage as a result. This was the start of the bad blood between Garrett, Cox and Print Rhode, Mrs. Cox's brother. Rhode was so angry he threatened to kill Garrett if he could get his hands on him, and nine years later, Rhode was said to have been seen talking to Wayne Brazel shortly before Garrett was shot. Coincidentally, Brazel was said to be riding the very horse that used to belong to Reed. Reed's horse, christened Loco because it went crazy whenever a gun went off, became a fixture of the Cox ranch after his death.

GARRETT'S ACCOUNT OF THE BRAWL WITH REED

Garrett gave his own account of this brawl at the Cox Ranch to newspapers of the time but mysteriously left out the comical tidbit about Fall's bulldog:

I threw down on [Reed] and he answered by knocking me with his fist and jumping through the window like a squirrel. I caught at him and tore his shirt off his back, but did not stop him...We fought hammer and tongs for a while, but at length he broke away, sprang through the door and, ran down the hall...Just then my Mexican came in, and, having no sentiment about it just whaled away and shot him in the back, killing him on the spot. The doctors said, when they examined the man's body, that he was the most perfect physical specimen they had ever seen...The Sheriff offered me the reward, but I would not take any of it. I told him I would be looking for someone over in his country someday, and was sure he would do as much for me.

As Garrett was always strapped for cash, it is hard to believe he would turn down the reward money. More likely, he spouted all this off to the press to make himself sound good.

SAVED BY THE BADGE

Another interesting Garrett adventure from this time period was collected by C.L. Sonnichsen via Herb McGrath, a foreman of the Diamond A Ranch. McGrath knew a young cowpoke he called "Tex" who one day became mixed up in a shootout in a bar in Deming. Two lawmen, aware of his rustling charges against Tex, approached him at the bar and told him he was under arrest. Tex quickly drew out his gun and cut both men down with lead. With the two deputies down, two men in the back playing cards went for their guns and aimed them at Tex, who shot one in the arm and frightened the other enough to drop his gun. Next up, the bartender went for his gun, which Tex supposedly shot right out of his hands. Tex rushed out of the bar, saddled his horse and was riding off when he saw a sheriff with a distinctive silver star pinned to his shirt chasing after him. Tex shot him right in the breast, and he fell to the ground, presumably dead. From there, Tex rode back to the Diamond A, where his friend McGrath advised him to ride for Mexico.

Sonnichsen concluded: "There were some interesting developments back in Deming. The last shot from Tex's pistol hit the star pinned on the left breast of the officer. Back of the star was a heavy silverine watch. The bullet hit so close to the officer's heart that it knocked him out for a while. He was a tough old frontiersman, however, and recovered quickly. His name was Pat Garrett."

LAST DAYS AS A LAWMAN

Garrett's last big hurrah as a lawman occurred in February 1900, when the George D. Bowman and Son Bank was robbed in Las Cruces. The robbers, William Wilson and Oscar Wilbur, made off with $1,000. Within only twenty minutes, Garrett and his deputies were on their trail, and by the next day, they had arrested six men who fit the robbers' descriptions, though no money was ever recovered. Eventually, Wilson and Wilbur were tracked six hundred miles away in San Antonio, Texas, where Garrett's deputy apprehended them and brought them back to Las Cruces. There it was learned that Garrett's old nemesis Print Rhode was actually an accomplice to the robbery. When Rhode and another man stood trial and pleaded not guilty, it was déjà vu all over again as they were defended by Albert B. Fall in the courtroom of Judge Parker and acquitted despite Garrett's best efforts.

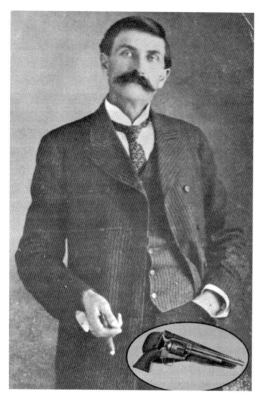

Pat Garrett during his tenure as sheriff of Dona Ana County. *HSSNM, #554.*

Around the end of 1900 and nearing fifty years old, Garrett decided not to run for reelection, though other sources also say he wasn't nominated. The county also owed him $4,000, and of all people, A.B. Fall fought to help him collect it. Pat, who was reported to finally show his age after the stressful Fountain affair, arrested one more fugitive in Alamogordo before his tenure was up. It was a somewhat inauspicious affair involving a man wanted for a similarly inauspicious charge. Garrett said of the incident:

I stepped up to him, and tapping him on the arm, told him he was under arrest. But that fellow, thinking I was unarmed, my gun being out of sight in my hip pocket, turned on me like a wildcat and ranted and swore and abused me something scandalous. I took it for a minute. It had been a long time since I had been in a row. I hardly knew what to do; I didn't want to kill him. Says I to myself, "Pat, you must be getting old, you're losing your nerve." Then, all of a sudden, the feeling of old times came over me. Maybe I got a little mad; I don't know. But I jerked out my gun and stuck it against his stomach so hard it made him bend double. His hands went up like I'd touched a spring. "It's alright old man," he said as meek as a lamb, "but I'd give just a hundred dollars to know where you got that gun." I guess I was a little too quick for him.[59]

Presumably, this was Pat's last arrest as a peace officer but not his last row. He would have several of those before he kicked the proverbial bucket.

FRIENDS AND FOES OF PAT GARRETT: OLIVER LEE

Born in Buffalo Gap, Texas, in 1865, Oliver Lee first came to New Mexico Territory in 1884. Right off the bat, he became engaged in a violent range war with the Good family in the Tularosa area. Lee's best friend, George McDonald, was killed in one of the shootings, and Lee carried the bullet that killed him on the end of his watch chain in his memory. Lee's famous Dog Canyon Ranch itself was only obtained when a lone Frenchman who owned the property was mysteriously killed, with many speculating Lee had something to do with it.

When Lee was accused of killing Albert J. Fountain he became a sympathetic media sensation. Leon Metz wrote, "Overnight [Lee] became a six-gun Robin Hood. In the Southwest Sherwood Forest Gililland was Little John and Garrett the sheriff of Nottinghamshire." Perhaps it was like history repeating itself for Pat Garrett, as Lee became a sort of Billy the Kid figure, wooing the press.[60] Dee Harkey said of Lee, "He could kill with a six-shooter with the same calm and accurate demeanor that characterized Billy the Kid."[61] In her 1947 article, May D. Rhodes asked Gene Rhodes who was the better shot, Billy the Kid or Lee? Gene replied, "The answer is self-evident. Oliver Lee is alive and Billy the Kid is dead." Mr. Lee had a good laugh later on when he heard of this exchange.

Unlike the Kid, Lee conveniently slipped from Garrett's clutches and many years later even became a state senator from 1922 to 1924. Lee died of a stroke on December 15, 1941. Lee's Dog Canyon Ranch was forever immortalized as Oliver Lee State Park, created in 1980, while by contrast, all poor Garrett has in the Las Cruces area is his grave. Supposedly, in a cemetery in Ruidoso exists a nameless headstone that simply reads, "He disagreed with Oliver Lee."

BAWDY TIMES IN EL PASO: 1901-04

He was personally known to more men in the Southwest than any other man in the country, and was known by reputation almost throughout the entire country as the slayer of the desperado, William H. Bonney, alias "Billy the Kid."
—*John Milton Scanland,* Pat F. Garrett and the Taming of the Border Outlaw

After the assassination of President William McKinley in early 1901, Theodore Roosevelt took his place in the Oval Office. Having a soft spot for old western relics, no one had to twist Roosevelt's arm when Garrett's name came up to replace the current custom's collector in El Paso, though he did receive many letters for and against appointing Garrett.[62] Former New Mexico governor and author of *Ben Hur* Lew Wallace sent a letter of support for Garrett, as did John Nance Garner and even Garrett's on-again, off-again enemy Albert Fall.

Eventually, Roosevelt decided to appoint him the position, but before he could be appointed he had to prove that he was literate by reading aloud the following proclamation: "I, the undersigned, Patrick F. Garrett, hereby give my word of honor, that if I am appointed Collector of Customs at El Paso, Texas, I will totally abstain from the use of intoxicating liquors during my term of office." Of course, upon learning that he had gotten the commission, the first thing Pat did was make tracks for the Coney Island Popular Resort to go drink. Even A.B. Fall came calling to get in his old enemy's good graces, but Garrett gave him the brush off. Garrett also had to convince

El Paso, Texas, during the early twentieth century. *HSSNM, Larkham Album 3.*

a skeptical senator that he was not a gambler, with Garrett innocently remarking that he didn't know the difference between a straight flush and four of a kind. Ironically, soon after, Garrett was roasted at a luncheon where his gambling habits were made fun of with one man proclaiming, "Everybody in El Paso knows that Pat Garrett is not a poker player. He just thinks he's a poker player."

Garrett officially took office on December 20, 1901, and bought a house in El Paso. However, the Coney Island Saloon was Garrett's real home for the next four years, as that was his favorite spot. In *Pat Garrett*, Richard O'Connor humorously wrote that the atmosphere there mellowed Garrett to the extent that he could "even converse genially with Albert B. Fall." Garrett was also a tourist attraction of sorts there, often pointed out to passersby as the killer of Billy the Kid. The one-eyed saloon owner, Tom Powers, who also had a soft spot for western heroes, quickly took the deceased Ash Upson's place as Garrett's best friend and drinking partner. And if the old saloon's walls could talk, one could probably write from its reminisces an Old West version of *Cheers*, with Pat presumably the equivalent of Norm and scheming intellectual A.B. Fall that of Frasier Crane.

TOM POWERS MEETS BILLY THE KID

Perhaps its too much of a coincidence that Texan Tom Powers could have known both Pat Garrett and the man who made him famous, Billy the Kid. In an interview between Leon Metz and Mrs. Tommy Powers Stamper, his daughter, Stamper related a story about her father running into an unusually profane Billy the Kid when he was a cowhand in New Mexico. Powers claimed he had just laid down after a hard day's work on the range when the Kid rode up and asked, "Where's the boss of this outfit?" Before Powers could answer, the Kid gave him a thorough cussing and drew his gun on him. Soon, the other cowboys came on the scene and Billy rode off. After the incident, Powers vowed never to take his gun belt off again. To his horror, the Kid got hired on as a hand, and so for the next three nights, Powers refused to sleep, fearful the murderous Kid would come and get him. "My father didn't get a wink of sleep because he was watching that SOB all night. But one night, Billy packed his roll and rode out. Papa was the only one who saw him because everyone else was asleep." The next day, a sheriff's posse came riding through looking for the Kid, and Powers pointed them in the right direction. From then on, Powers was wary of ever running into the Kid again. Of the outlaw, Powers's daughter quotes him, "'You [can] make a hero out of that son of a bitch if you want to, but he wasn't when [I] met him. He was a lowdown ——,' all of those names. When Papa called you one of those names, you usually were one."

THE TUCK-CRAIG DIAMOND AFFAIR

In a story that would be right at home in a Sir Arthur Conan Doyle Sherlock Holmes novel, Pat investigated a diamond-smuggling case during his tenure as collector of customs. Had it been written as such, it would've likely been known as "The Tuck-Craig Diamond Affair." It involved the swindling of a lonely window, whorehouse snitching and even fortune telling centered around a pair of swindlers made up of a "Mrs. Tuck" and her lover, a gambler known as Mr. Craig. The duo took great pains not to be seen with each other and began collecting scandalous gossip about the town's wealthier citizens, the focus of which was wealthy husbands who visited houses of ill repute. Armed with this information, Craig set up shop as a "fortune teller" and soon became very popular with the womenfolk. To quote from Owen White's book *The Autobiography of a Durable Sinner*, which recounts the

escapade firsthand, "To judge by the reform that blighted the lives of some of El Paso's gayest married men the girls got their money's worth."

When Craig ran out of gossip to sell, he turned to romancing a wealthy widow high up in years, Mrs. Brenner. The intricately complicated scheme revolved around some mysterious diamonds owned by Mrs. Tuck that she could not redeem for herself in America. The plan was for Mrs. Brenner to take them overseas to London, where she would redeem them for $20,000 and then bring them back to America. The plan worked, and not only did Mr. Craig take Mrs. Brenner to London, on the way back he made her Mrs. Craig. Not long after, the same diamonds were glimpsed in the window of an El Paso pawnshop. With the smuggling allegations being gossiped about, Garrett was called onto the scene and scooped the diamonds into a bag for investigation. As he conducted his investigation, and in the process became enamored with the beautiful Mrs. Tuck, scandalized citizens and gossip hounds such as A.B. Fall loaded Garrett up with drinks at the Coney Island to get Garrett to talk. According to White, "Having interviewed [Mrs. Tuck], Pat of course knew [the story], but that evening at eight o'clock when I saw him in the Coney Island, indulging in his regular nightly bout with Old John Barleycorn the tall killer's thin lips were more firmly set than in a long, long time. This was a bad omen for the barflies." Said barflies remained disappointed as Garrett wouldn't break, and they would have to remain content with speculating what went on between Garrett and Mrs. Tuck (Mrs. Tuck had no husband; Mr. Tuck was purely fictitious). However, Garrett was no Inspector Clouseau in this "jewel heist" and managed to solve the case. The diamonds did, in fact, originally belong to Mrs. Tuck, who lacked the funds to redeem them, but she did have invoices proving they had been purchased legally in Philadelphia sometime previous. The diamonds were then returned to the pawnbrokers, and Craig used the very money he pawned them for to redeem them and re-gifted them to Mrs. Tuck, who now legally possessed them once again. Soon, Craig divorced the poor widow woman and reunited with Mrs. Tuck. The two not only got away with their scheme, but the hedonistic El Pasoans even applauded their fellow sinners' actions.

And it could well be that the whole fiasco was just as fictional as one of Conan Doyle's stories, but for the record, it does appear in Owen P. White's own autobiography, which he no doubt embellished. Born in 1879, White was a famous scandal sniffer and muckraker from El Paso. *Durable Sinner* was so controversial that before publication it was recalled so that a chapter dealing with R.B. Creager could be removed. If that's any indication, then perhaps the story regarding Garrett was also true.

PAT GARRETT VISITS THE REAL CONEY ISLAND

Early in Pat's tenure as collector of customs, he caused a furor when he himself assessed a large herd of Mexican cattle crossing the border rather than hiring an official inspector to do so. As he counted the cattle too accurately, he soon outraged the ranchers and found himself in the midst of quite a scandal, one that warranted a trip all the way to New York. The purpose of the visit was so that he could defend himself before a board of appraisers. While in the Big Apple, Garrett visited a shooting gallery at Coney Island, which caused another furor reported on in an *El Paso Times* article dated July 19, 1902:

> *Collector Pat Garrett of El Paso, Tex., six feet four in his stockings, and afraid of no man who ever drew a gun, will not be made welcome if he makes another trip to the shooting galleries at Coney Island. The tall Texan is in New York, stopping at the Marlborough hotel, and will appear before the board of appraisers at a meeting to be held tomorrow in connection with appraisements he made on a lot of Western cattle, and which were disputed by some Texas cattlemen. To pass the time since his arrival last Saturday, he has been visiting adjacent resorts.*
>
> *He went to Coney Island today and will not be soon forgotten by the proprietors and habitues of a least two shooting galleries there. Accompanied by several friends he first stopped at the one nearest to the boat landing.*
>
> *Picking up one of the little rifles and examining it with a critical eye, he remarked: "I reckon I'll try three shots just to keep my hand in."*
>
> *He took what seemed to be a careless aim at one of the big round targets and fired, but there was no mark to show where the bullet struck.*
>
> *With a superior sort of smile, the proprietor reloaded the gun and handed it to the collector for a second trial. Again, there was no little black speck to mark the impact of the bullet on the target, and then it began to dawn on the proprietor that a careful search in the exact center of the bull's eye would reveal one little spot where both bullets had struck.*
>
> *About that time, the collector began to warm up to his work and the fun began for a crowd that quickly collected when it was noised around that a real Western sheriff was giving a free exhibition of the way they shoot in Texas.*
>
> *Within half an hour, the collector had collected a box and a half of cigars, all there were on hand, after breaking every clay pipe in sight and making a record for bull's eyes that never has been equaled on the island.*

During the afternoon, he gave the proprietor of another gallery a similar surprise.

"There's a whole lot of nonsense talked about shooting in Texas," said the collector today. "I never fired a gun in my life except when there was something for the gun to do, and except when they are on duty, my deputies don't carry guns. Out there we have our doubts whether the fellows who race through towns blazing into the air would stand very long on a real firing line, and that sort of business is mostly done away with nowadays, anyhow."

SCANDAL!

The scandal over the Mexican cattle continued to haunt Garrett when he returned to El Paso, as his efforts in New York had failed to smooth things over. A representative of an American importing firm, I.A. Barnes, was calling for Garrett's removal. Roosevelt sent Joseph Evans, a special treasury agent, to investigate. This resulted in Garrett being forced to hire George Gaither to inspect cattle for him in the future and culminated in a comical brawl between Gaither and Garrett in the streets of El Paso, creating another scandal in the process. Somewhat like the climactic John Wayne brawl in *The Quiet Man*, twenty-five El Pasoans watched excitedly from the street following the fight as it went. Eventually, the fight, which the *El Paso Evening News* called a "comic opera," was ceased when the two were separated and arrested. Each paid five dollars for disturbing the peace, and for what it's worth, crusty old Garrett gave Gaither a thorough ass beating (or, in the more refined colloquialism of the day, "gave a splendid account of himself").

Garrett later ran into A.B. Fall on the street, and Fall chided him for the incident, saying, "I hear that you had a fight with Gaither this morning. You'll learn not to come down here and tangle with those Texans."

"Albert, do you not remember that time at Cox's ranch when that little Gene Rhodes chased you all around the corral and beat you up so bad that we had to pull him off and take you to the house for a drink of whiskey to bring you back to life?" Garrett replied.[63]

"I don't remember a thing about it," Fall said and tried to keep from grinning.

While Fall was currently an ally, Garrett made new enemies in El Paso to fill the void, one of whom was Tobe Tipton, then a disgruntled ex-bartender from the Coney Island fired by Powers. Tipton was one of several petitioning for Garrett's expulsion from El Paso.

In the end, it was a mere photograph that toppled Garrett's regime in El Paso. When invited to attend the 1905 Rough Riders convention, Garrett brought along his best friend, Tom Powers, who he introduced to President Roosevelt as a prominent cattleman, not wanting anyone to know of Powers's less-than-respectable reputation. A photo featuring all three men surfaced courtesy of Garrett's enemies (it was rumored to have been stolen from Powers's office in the Coney Island) and caused a scandal when it leaked to the press. Roosevelt became angry at Garrett, and as such, the former lawman was not reappointed when his term was up. Rumors even circulated that Secret Service men began tracking down and destroying all spare copies of the photos that they could find.

Other sources say Roosevelt told Pat, "I don't mind what you did to Theodore Roosevelt as an individual, but you insulted the dignity of the president of the United States." Morgan Nelson, whose grandfather once worked for Garrett, says the real reason Garrett got fired was that he counted the cattle coming in and going out too accurately, which enraged the ranchers, who wanted him gone. Whatever the case, Pat learned on December 13, 1905, that he would not be reappointed. Supposedly, had this not happened, Garrett may have even stood a chance becoming U.S. ambassador to Mexico.

SOPHIE POE WEIGHS IN ON GARRETT

Sophie Poe, the wife of Garrett's friend/ enemy John W. Poe, said that long ago she had been warned to be cautious of men with green eyes, which she said Garrett possessed. Mrs. Poe provided some interesting insights into Garrett's time as customs collector in El Paso, though they are likely hearsay. Mrs. Poe claims Garrett campaigned hard to become ambassador to Mexico at the time but was turned down because President Roosevelt was made aware of Garrett's penchant for prostitutes. Author of a well-received

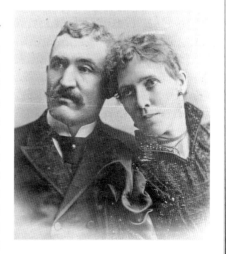

Sophie Poe. *HSSNM, #1206.*

memoire, Buckboard Days, *Mrs. Poe was later asked to consult on Howard Hughes's Billy the Kid film* The Outlaw *(1943), as were the Garrett children. The Garrett children were so upset by the portrayal of their father that Mrs. Poe claims they were ready to sue Hughes for defamation of their father's image. Mrs. Poe remarked that "they better not call her to the stand or she [would] tell them what their father was really like."*

FRIENDS AND FOES OF PAT GARRETT: ALBERT B. FALL

One man who served a tedious position in Garrett's life as both ally and enemy was Albert B. Fall. Born in 1861, in Frankfort, Kentucky, Fall became a lawyer and began his legal career in Las Cruces, New Mexico, in 1887. He soon butted heads with Albert Fountain and, as a result, Garrett, too. However, from time to time, Fall aided Garrett at certain times of his life rather than hinder him.

The two seemed to be on best terms when they were both living in El Paso at the same time. Often, the two frequented the Coney Island Saloon together. Scheming Fall even managed to earn himself $30,000 through a scandal involving streetcars, of all things, during his time there when he was a member of the legislative council (having at this point switched over to the Republican Party). Fall's main claim to fame was a scandal that rocked the nation when he served as secretary of the interior under President Warren G. Harding in the 1920s. The Teapot Dome Scandal alleged that Fall had taken a $100,000 bribe to allow development of the naval reserve Teapot Dome oil field in Montana. Others say Fall was innocent and that he was more or less framed. Fall himself said that secret documents existed within Washington, D.C., that could exonerate him, but they certainly never surfaced at his trial, where he was sentenced to one year and one day in prison.

Morgan Nelson recollects, "As a lad of 10, I remember vividly the picture of a sick, senile, old man being hauled off to the New Mexico Penitentiary in an ambulance to serve a one year sentence. He served that sentence and was then sent home to die. To his dying day this broken, once proud old man, who had served in so many public offices in New Mexico, the United States Senate, and as Secretary of the Interior in President Hardin's cabinet, protested his innocence. No one believed him."[64]

As for Garrett, he had his last meeting with Fall immortalized in a photograph along with several other prominent southeastern New Mexicans in 1907 at the inauguration of Governor George Curry, a mutual friend. Richard O'Connor wrote, "A fatalist would undoubtedly be impressed by the number of occasions on which Garrett and Fall were thrown into each other's company."

THE DEATH OF PAT GARRETT: 1905-08

Who, in the end, suffered more from the shot fired eighty years ago in Pete Maxwell's shadowy bedroom?
—Richard O'Connor, Pat Garrett

After leaving El Paso, Garrett's life spiraled down the tubes, and he moved back to Las Cruces, where he could be close to his enemies again (though he also hoped that newly appointed governor George Curry would make him the new superintendent at the territorial prison in Santa Fe). Garrett wasn't unaware of his hostile circumstances and often remarked to Cesario Pedragon that he expected to "die with his boots on" just like his old friend the Kid. According to lore, Garrett carried his shotgun everywhere and slept with a six-gun under his pillow at night.

In the "Tragic Life of Pat Garrett" Joe Heflin Smith quotes an unnamed old-timer who stated, "I knew Pat Garrett in 1907 and I never saw a man more beaten than he was. Nothing had worked for him. He didn't have much land, and it was desert." Likewise, Kenneth Oliver once said of Garrett, "When I was in Las Cruces, I got a good long look at Pat Garrett…He was in a bar and did quite a lot of loud talking. He had let liquor get the best of him. I didn't care for him and I don't think that many did. He was overbearing. You take any man like that and let him get a snootful of liquor and he's dangerous."[65]

Pat's numerous get-rich-quick schemes and various rage-filled exploits toward the last few years of his life nearly sound like week to week plots for

episodes of some macabre sitcom. During this period, Garrett became a lawyer, lasting only one trial, which he lost; made his son prospect for gold with a pickaxe in vain all over their ranch; engaged in various street brawls (Garrett threatened to bludgeon Emmett Isaacs with a double piece of rope, all because Isaacs objected to the method in which Garrett drove away some cattle from a watering hole) and rumors of street brawls (Garrett was said to have banged his Colt .45 across the head of gigantic Jim Baird over a poker game feud, but historian Robert N. Mullin says this is highly unlikely, for if Garrett had attempted such an act he would have been killed); and even moved in with a prostitute in El Paso. After Garrett's death, Albert Fall wrote that "he had three or four fist fights in Las Cruces, shortly before his death and got the worst of it; even Pancho Amador gave him a good beating. Everyone was afraid that he was going to kill someone and a sigh of relief went up when he was finally killed."[66]

Supposedly, Fall was the member of a conspiracy to kill Garrett, which began when W.W. Cox called together a meeting in the El Paso St. Regis Hotel of all of Garrett's enemies: Oliver Lee, A.B. Fall, Jim Miller, Carl Adamson, Mannen Clements, Bill McNew, Print Rhode and Jesse Wayne Brazel—a sort of Wild West version of the Legion of Doom. The only one missing was Brushy Bill Roberts, but as he had yet to rise to prominence, he wasn't available for the supposin' of the old-timers to further flavor the tale.

Supposedly, Cox's reasons for wanting his neighbor dead were threefold: first, he wanted Garrett's land for its water; second, he wanted revenge for his wife's miscarriage; and lastly, he feared Garrett would reopen the Fountain case.[67] Cox would foot the bill for the killing,[68] but seeing as how he couldn't get away with coldblooded murder, they needed an excuse to provoke Garrett. As it so happened, Garrett had borrowed a considerable sum from Cox, who in turn held a mortgage on Garrett's land and some of his cattle. To force Garrett into desperation, he would let the mortgage lapse, which would put pressure on Garrett when his bank learned about it. With the knowledge that Garrett hated goats, as did all cattlemen, they decided Brazel could lease some of Garrett's land for horses, which he would later swap for goats. Fall would draw up a binding contract that Garrett couldn't escape from, and when Garrett became irate over the goats, Carl Adamson would come along to buy the land and the goats. That is, until he and Brazel had an argument that would infuriate Garrett, paid assassin Miller could shoot him from a distance and Brazel would be the sympathetic "fall guy." Most consider this story a fairy tale, including Leon Metz, who summarized: "There it is, the motive, the conspiracy, and the murdered—enough romance

and mystery for a saddlebag full of paperback thrillers. It seems a shame that none of it is true." Among the more credible believers in this scheme were even Charles Siringo, the cowboy detective.

And remarkably, the very scheme paragraphed above, likely did take place in some form or another, as Garrett did indeed end up dead, thanks to the goat scheme.

PAT GARRETT: ATTORNEY AT LAW!

Shortly after his expulsion from El Paso, Garrett was investigating a double-murder in Mexico on New Year's Day 1906. He did this not as a lawman but as a lawyer, as Garrett, a true "jack-of-all-trades," was licensed to practice law in Mexico. Garrett's defendant was American rancher O.E. Finstad, accused of murdering his brother-in-law and another man, while Finstad claimed they were all attacked by "assassins." Naturally, as the man's defense lawyer, Garrett agreed that he was innocent, and a band of "assassins" had indeed done the killing. Ironically, Garrett now found himself in the position of his old nemesis Albert Fall, defending a man who may very well have been guilty. Garrett didn't have Fall's luck though, and Finstad was sentenced to life in a Chihuahua prison. But lucky for Finstad, he got busted out by Mexican Revolutionaries later on.

THE PLOT TO KILL GARRETT PLAYS OUT

The more credible historians ascertain that Garrett's eldest son, crippled Dudley Poe, leased Garrett's ranch land to Jesse Wayne Brazel while Garrett was away cheating on Dudley's mother in El Paso. As it turned out, it would be the death of his father. Though Brazel had yet to meet Garret Senior, he was himself in league with Print Rhode, who hated Garrett for the incident at the Cox ranch wherein Rhode's sister suffered a miscarriage. When Garrett found out goats were grazing on his land, he dropped Mrs. Brown (the prostitute) and raced home angrily in his buggy to rid his land of the goats. Other sources differ and say that it wasn't Dudley who set up the deal between Brazel but that it was Pat who believed he was leasing his land to Brazel to graze horses upon. In "Neighborhood Talk of Pat Garrett," C.L. Sonnichsen relates, "A.B. Fall…drew up the papers, and since there was no love lost between Fall and Garrett, Fall made the lease ironclad—no

loopholes at all—but Pat did not find that out for some time. He signed it, and a few days later it was said he told some of his Las Cruces friends how he had leased his ranch to 'that young sprout Wayne Brazel and got the best of him.'"

"How did you do it?" a man asked Garrett.

Scheming Garrett replied, "Wayne's horses will go further from water to graze than cattle and my cattle can water at the same place as the horses."

One of the listeners then informed Pat that Wayne was using the land for goats instead, and Garrett flew into a rage. According to Sonnichsen, Brazel was forbidden by Garrett to put the goats on his land but then did it anyway. Garrett sent threats to Brazel to bluff him off, but it didn't work.

As legal efforts to push Brazel off his land failed, Garrett thought he had found his salvation when Carl Adamson and Jim Miller came calling to buy his land. He was wrong—they were his damnation instead. Miller was in fact the infamous paid assassin Jim "Killer" Miller, and Adamson was a crooked Roswell man who claimed he wanted to buy Garrett's land for some Mexican cattle he and Miller owned, when it later turned out there likely never was any cattle. Supposedly, the duo existed only to bait Garrett into a fateful trap along with Brazel.

During Garrett's negotiations with Adamson, strange things happened near the ranch, and a tangible air of trouble seemed to be brewing. One night before the tragedy there were prowlers on the ranch, or so suspected Frank Adams the foreman. Garrett brushed off his claims and went back to bed. The next morning, hoof prints were found.[69]

Carl Adamson arrived at the Garrett Ranch on the evening of February 28. Legend has it that Brazel also secretly dropped by to deliver a note to Adamson, said to be his instructions for the next day. Earlier that same day, Brazel, Adams and even Print Rhode were busy sending telegraphs back and forth to Jim Miller, slated to do the shooting. Miller, it was believed, began his ride to Las Cruces that night.

What is known for certain is that Adamson did stay the night at the Garrett ranch and the next morning ate breakfast with the Garretts under the suspicious eye of Apolinaria, who never trusted him from the start. When Pat mentioned grabbing his revolver before setting out for Las Cruces, where he, Adamson, Miller and Brazel were to meet, Adamson was quick to mention that he shouldn't need it. Garrett had dressed very nicely for the trip with unusual care, as though he knew he was preparing for his own funeral, for only a few short hours later he would be shot dead after Adamson claimed Garrett went after Brazel with a shotgun.

According to C.L. Sonnichsen, Pat's young son Oscar was originally to ride with Adamson and Garrett into town and was very excited to do so.[70] Instead, he slipped on his mother's freshly mopped floor, busted his knee and had to stay home. Had Oscar gone along, the whole affair would have possibly brought the Albert and Henry Fountain murder full circle. For if there really was a conspiracy to kill Garrett, little Oscar would have to have been done away with himself, or on the other hand, perhaps the assassination would have been aborted altogether. After all, they couldn't claim little Oscar went after anyone with a shotgun.

As Garrett left his home, he promised to come back with a present for his daughter Pauline, the last of his children to see him alive. Pauline claims she could see Wayne Brazel a short distance away following the wagon, but the fateful shooting wasn't to occur just yet. First, Garrett, Adamson and Brazel, who had since joined them on the trail and had already begun arguing with Garrett, stopped in at the Organ mining camp at the general store of L.B. Bentley.

Bentley claimed that when the trio entered his store discussing the terms of sale, Garrett was so angry his jaw was shaking. The last thing he heard as they left was Wayne Brazel stating, "But Pat, I can't get those goats off."

Back on the trail, as the trio reached Alameda Arroyo, the sore subject of the kidding goats, which now outnumbered what Adamson was willing to pay, was brought up again. Originally, 1,200 goats were thought to be on the land, but Wayne informed him it was closer to 1,800 now, and Adamson began backing out of his offer to buy them, which would leave Garrett high and dry in the process. This, it was said, sent Garrett into his final frenzy. Adamson, at this fever pitch moment, had asked to get out either to urinate or check the bridal on a horse. Pat said to Brazel he would get him off his land one way or the other and went for his shotgun (in fact loaded only with birdshot). Brazel whipped out his revolver and shot him twice. Brazel's two bullets would turn out to be a precursor to the magic bullet that would one day kill John F. Kennedy. For despite shooting Garrett to the face in "self-defense," the bullet entered through the back of Pat's skull.

Other stories allege instead that once Adamson reached the designated "killing spot" he asked Garrett if they could stop the buggy. Garrett got out to urinate, and Jim Miller raised up from behind a sand dune and shot Garrett in the back of the head. As Garrett spun around he shot him again through the chest. Miller took off quickly so as to keep a schedule for an alibi he had cooked up in Fort Worth.

Whoever shot him, at the exact moment Garrett died the entire family at the Garrett ranch claims that a heavy solid oak board used to prop open

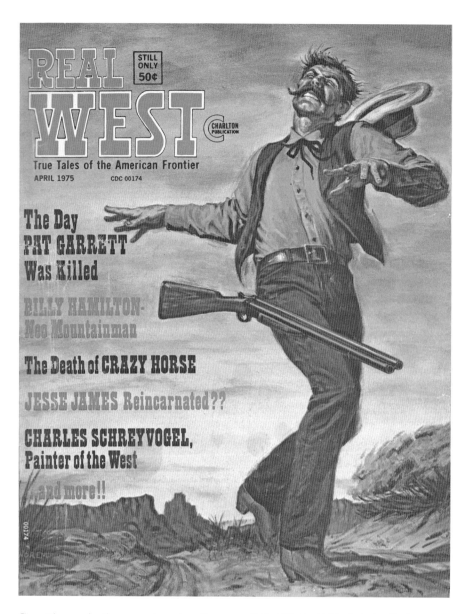

Garrett's assassination as portrayed on the cover of *Real West* in 1975. *Author's collection.*

the door tipped over mysteriously for no reason, creating a startling "Bang!" Apolinaria exclaimed, "Something has happened." Dogs began howling outside and didn't stop for another twenty-four hours while Apolinaria stayed in a state of inconsolable shock. They didn't receive confirmation of

Garrett's death until midnight. In "Pat Garrett's Last Ride," C.L. Sonnichsen wrote, "By nightfall the day of the shooting the whole territory knew that Garrett was gone—and that not all the tale had been told."

The next day, the family went to Strong's Undertaking Parlor and saw Pat stretched out across five chairs because there was no coffin long enough to hold him; it would have to be special ordered. President Roosevelt sent his condolences to the family as did Emmerson Hough and others. Garrett's death was the biggest news to hit the territory in years. Not since the disappearances of the Fountains—who some street corner philosophers whispered the new murder was related to—had the Organ area erupted into such a frenzy.

Only two days after the killing, Dudley Poe, charged Brazel (who it should be noted had turned himself in to the sheriff and confessed to the shooting) with murder, and reportedly two days after that Dudley received a letter informing him that he could be killed just like his father. The enigmatic letter written in pencil stated among other things that "Brazel shot Garrett from the back and *another* [emphasis mine] from the front. Hanging without a trial is what Brazel should get." It was signed simply, "One Who Knows." Newspaperman John Milton Scanland remarked, "As Carl Adamson was the only witness to the tragedy, and as that fact was well known, it is very strange that anyone should sign himself as 'One Who Knows.' This deepens the mystery surrounding the strange tragedy."[71]

Annie Garrett also received an anonymous letter around this time identifying Print Rhode as being a party to the murder. Early articles from the time also questioned the circumstances, and one noted that Pat Garrett wouldn't have made a threat; he would've shot first, nor did he have to get out of his buggy to shoot Brazel. The town was astir with gossip. Jack Carter wrote in his article "Some Facts on Wayne Brazel" that "a prominent man in Las Cruces advised some of Wayne's friends to go to the undertaker's and look at Garrett's body, as Tom Powers…was telling everyone that Brazel shot Garrett in the back and should be hanged." The "prominent man" may have been Fall, who frequented the Coney Island Saloon.

Before Pat could even be buried, a preliminary hearing was held on March 3, 1908, and it seemed to be a cheery atmosphere for a hearing on a murder. Wayne Brazel stared out the window, seemingly unconcerned, while Adamson made the huge crowd of spectators laugh several times as he recounted his story, which it should be noted he had since changed

slightly. Also the trial for Brazel was set for next year, with his bond set at $25,000. Once the judge learned Brazel's friends could pay the $25,000 bond easily, he raised it to $50,000 until someone more schooled in legal matters than he informed him he couldn't raise the bond after it had been set. The bond was quickly paid by a group of men lead by W.W. Cox.

Pat was buried on March 5, 1908, in the Las Cruces Odd Fellows Cemetery next to his daughter Ida, who had died eight years earlier. Newspapers of the time wrote:

> *"Pat" F. Garrett, the slayer of "Billy the Kid," was killed by Wayne Brazel, near Las Cruces, New Mexico, on the morning of February 29, 1908. The weapon used was a six-shooter and the first shot entered the back of the head and came out over the left eye; the second ball entered the lower breast and ranged up about nine inches into the shoulder blade. Garrett died instantly, and without speaking…"Pat" Garrett, the famous hunter of desperados, was buried in the little graveyard at Las Cruces (the Crosses) on the following Thursday. The cortege was covered with floral offerings, and followed to the grave by his many friends. The funeral was delayed at the request of his brothers, John and A.J. Garrett, of Haynesville, Louisiana, who desired to attend. The pallbearers were: Hon. George Curry, Governor of New Mexico; Harry Lane, Morgan Llewellyn, Numa G. Buchoz and Thomas Powers…Though simple and not attended by ostentation, the ceremony was very impressive, and there were tears for the brave and generous "Pat" Garrett as his mortal remains were consigned to earth.[72]*

As though a final cruel joke, Pat Garrett's grave doesn't even register as a tourist destination compared to Billy's grave in Fort Sumner. Adding insult to injury was the Billy the Kid Museum in Mesilla, only twenty short miles away from the grave. About eight years after the criminal Billy the Kid got a formal grave marker, and two years prior to his getting a second formal grave marker, in 1938, Jarvis Garrett did the best he could to erect a crude concrete memorial at the site of his father's death. In recent years the Pat Garrett's Last Day Tour, which takes visitors along the route and last stops on the day of his demise, was created.

BERT JUDIA WEIGHS IN ON PAT GARRETT

Bert Judia was born in Organ, New Mexico, and there was certainly no love lost between him and Garrett, whom he loved to slander. Judia claims that on one occasion he came across Garrett on the trail to Organ, both men on horseback. Pat ordered Judia to get up on the hill so that he could get a better look at the horse's brand. Judia felt this was Pat's way of setting him up for a shot in the back. "If you can't read this brand your eyes must be bad. You know this brand, and you know me." Judia said. Garrett then oddly tried to get him to trade horses with him, which Judia also thought was a ploy. When Pat said, "Let's have a drink," and started to reach into his saddlebag Judia was sure he was really reaching for his six-shooter. "Pat, you better not try that!" From there, Pat quit trying to kill him, and Judia rode off a little quicker for Organ. "I could just feel that old bullet. I knew he was the kind who would shoot a man in the back." Judia's slander wasn't limited to Garrett but also extended to Garrett's foreman—"if you can call a man who has one employee in charge as a foreman"—Frank Adams and his lone Mexican worker who used to wander into Organ to "beat up drunks" according to Judia.

FRIENDS AND FOES OF PAT GARRETT: W.W. COX

Either the greatest nemesis, or possibly the best neighbor, that Pat Garrett ever had may well have been W.W. Cox. Cox was a rough character who was a veteran of something similar to the Lincoln County War in Texas called the Sutton-Taylor Feud in which much blood was spilled. There is even a fanciful legend that Cox was thrown in prison for several years as a result. When first incarcerated, Cox had a sack of peaches with him and would sporadically throw the seeds out the window. Eventually, a peach tree grew large enough that it reached his window, and he used it to escape, or so legend says. Cox then fled to New Mexico, where he started a ranch in Dona Ana County with his wife and children. The Cox ranch, better known as the old San Augustine Ranch, was described by Bert Judia as a "long adobe building on a hillside" with "big windows reaching almost from the ceiling to the floor." Judia describes the characteristics of the ranch as being a rough one, saying no man left the bunkhouse or entered the corral without a gun on his hip.

Cox was peculiar in that he dressed the same way every day no matter what he was doing, even branding cattle. His constant attire included a white shirt, a white starched

collar, a string tie and a vest. Reportedly, he was a master of profanity and managed to use the word "sonofabitch" in his every sentence.

Initially, he and neighbor Garrett were on good terms, this despite the fact that Cox was Oliver Lee's brother-in-law. Supposedly, the bad blood began while Cox was away in Mexico and Garrett's deputy shot and killed the fugitive Reed on Cox's ranch in front of his pregnant wife who suffered a miscarriage. Others say there was no bad blood, evidenced by the fact that Cox later loaned Garrett money and helped him out through various hard times. However, Garrett's failure to repay the debts may well have caused animosity between the two, despite the fact that Cox often sent food to Mrs. Garrett and the children when Garrett was away squandering his money in El Paso.

Interviewed by Eve Ball in her piece "The Real Pat Garrett," Cox's foreman Bert Judia implies Cox received a threatening letter from Garrett once. "One day W.W. asked me to ride up the canyon with him. He drew an envelope from his pocket and handed it to me. It contained a typed letter and a piece of paper torn from a magazine. The picture of a coiled rattlesnake was used for a signature. The letter advised Mr. Cox to take his family for an extended vacation." For whatever reason, Judia claimed the letter was from Pat Garrett, currently the customs collector in El Paso. C.L. Sonnichsen concurred in Tularosa and wrote that "it was justifiable also to kill an enemy who had been warned. Once an undesirable neighbor had been notified to leave the country, he stayed around at his own peril. If he absorbed a bullet at any time thereafter, he was considered to have committed suicide."

Only a few weeks after Pat's death, Cox bought his ranch from Apolinaria. Some argue Cox was lending a helping hand to the family, while others whispered he had gotten what he always wanted to begin with: Garrett's Spring—a notable water source on the ranch.

8
CONSPIRACY THEORIES AND INVESTIGATIONS: 1908-09

There is a mystery about this tragedy, and it may never come to light.
–John Milton Scanland, Pat F. Garrett and the Taming
of the Border Outlaw

At the very moment that Garrett was being planted into the ground in the presence of his family and esteemed mourners such as Governor Curry, two investigators handpicked by Curry himself were inspecting the scene of the crime with Carl Adamson: James Hervey and Fred Fornoff.

One of the first red flags Hervey and Fornoff discovered was a new Winchester rifle shell on the ground; Brazel and Adamson were claiming Brazel fired on Garrett with his revolver. Also if Garrett had intended to shoot Brazel from his buckboard, Pat should have been found dead in the buckboard. Instead, he was found lying on his back in a sand dune. Likewise, Dr. W.C. Fields in his investigation had found fresh horse manure and tracks where another mystery man had been watching or, more likely, participating in the killing. Later that night back in Santa Fe, Fornoff and Hervey concurred there was something fishy going on.

A month later, Hervey found himself in El Paso and decided to get in touch with Tom Powers at the Coney Island, as well as a Dr. Culinan. The trio agreed that with the proper funding an investigation into Garrett's death was worthwhile—all they needed was a private detective to go into the Organs undercover. Hervey next went up to Chicago to see Garrett's old pal Emmerson Hough, the famous writer for the *Saturday Evening Post*. Hough

wasn't interested in investing money in a detective because, as he explained it, Pat still owed him money. To top it off, he told Hervey, "Jimmie, I know that outfit around the Organ Mountains, and Garrett got killed for trying to find out who killed Fountain and you will get killed trying to find out who killed Garrett. I would advise you to let it alone."

Hough was one of several, including Jarvis Garrett, who seemed to think the Fountain investigation had something to do with Garrett's death. Supposedly, the reward money was still applicable if one solved the case, and money was always a good motivator for the broke Garrett.

Likewise, C.L. Sonnichsen wrote in *Tularosa*, "Anything that happened in the Tularosa country in the years that followed Fountain's death was linked to that event if local gossip could find a way to do it. When Pat Garrett was killed in 1908, there were those who said the Fountain business was behind it. The colonel's descendants still believe that Pat settled on his ranch in the San Andres because he thought the victims were buried on it or near it and he hoped to conduct the search unmolested."

To return to Hervey, after Hough's comments, the investigator decided to take a less aggressive approach in his detective work. In Hervey's article "The Assassination of Pat Garrett" written many years later, Hervey wrote that he advised Captain Fornoff that he should try to start "some kind of business in El Paso and see what he could find out. There were a bunch of tough characters still around El Paso, not the least of whom was Tom Powers himself. Another was Manning Clements, the brother in law of Carl Adamson, the sole witness in the killing."

Mannie Clements was rumored to be the weak link who the other conspirators feared would talk, which is supposedly what led to his death. Others stipulate it was merely the result of a feud between him and Albert Fall. Clements hated Fall because he defended the killer of his cousin John Wesley Hardin in court, and Fall hated Clements because he had tried to assassinate him for the act, twice. Clements's assassination attempts read something like a comedy sketch. On his first attempt to shoot Fall, Justice of the Peace Charles Pollock frightened him away, and the second time he shakily drew his gun at Fall he had it knocked from his hands by a "friend" and was promptly thrown out the front doors. When Clements was shot dead in the saloon on his next visit there on December 29, 1908, it was assumed Fall had a hand in the plot somehow. After the deed was done, Fall issued a proclamation to the police that they need not investigate the murder, which they ignored and arrested bartender Joe Brown. Some theorized that Brown indeed did shoot Clements and

was either paid by Fall to do it to keep him quiet, or perhaps by Powers in revenge for Garrett's death.[73] Brown was speculated to have had a gun under his polishing cloth, shot Clements in the noisy commotion and then dropped his gun into a tub of soapy water to conceal it. Whatever the case, Brown claimed Clements committed suicide at the bar, and Brown was not convicted. This happened, perhaps not coincidentally, before Wayne Brazel would stand trial for the death of Pat Garrett.

Clements was rumored to have handled the transaction between Jim Miller and "a rich rancher," likely Cox, though he is not named in Hervey's article. By this time, Hervey was beginning to make connections to the real possibility that Garrett was really gunned down by the assassin Miller.

Hervey had also suspected that one of his "regulars" in court, a ne'er do well named Joe Beasley, might know something to connect Miller to the killing, and he did. Beasley claimed that in Portales he had seen Miller, who was riding on to Las Cruces and needed a new horse to take him there. He forced Beasley to give him a new steed and to promise him an alibi stating that he was at this ranch at the exact moment Garrett was killed and then rode on to Cruces. Miller rode the horse so hard on its return trip that it killed it. Unfortunately, none of this information was put forth at Wayne Brazel's trial.

Brazel's trial was finally held on April 19, 1909, and is considered by many to be a formality at best and a joke by others since he was acquitted so easily. It didn't hurt that A.B. Fall was there to help. Fall was more than happy to come up from El Paso to help defend Brazel. According to Elizabeth Garrett, Fall came across her while they were both walking down the street in Las Cruces and stopped to offer his condolences. This is fairly brazen for several reasons, firstly since he was helping defend the man who killed her father, and second because Elizabeth was blind and wouldn't have noticed him anyway. Elizabeth promptly rebuked Fall, called him a hypocrite and asked that he not speak to her again.

Ironically, the star witness, Carl Adamson, wasn't even there, as Adamson couldn't testify because he had been convicted of smuggling Chinese immigrants into the country.[74] It took no less that fifteen minutes for the jury, which seemed to overlook that Garrett was shot through the back of the head, to find Brazel not guilty. An article out of Roswell a year earlier had wisely prophesied that Brazel would "probably be wholly exonerated on the ground of self-defense."[75] And in all likelihood, Brazel wasn't guilty of murder, but he was very likely guilty as a conspirator. It was something like déjà vu with Fall defending an accused murderer and Judge Frank W. Parker,

Elizabeth Garrett with her seeing eye dog in Roswell, New Mexico.
HSSNM, #3236.

the same judge who oversaw the Fountain case, presiding. The only person missing, naturally, was Garrett.

A party was thrown by W.W. Cox the next night in Brazel's honor. The previous day, coincidentally the same day of the trial, Jim Miller had also attended a party, specifically a grand necktie party—one of the fatal varieties partial to the Old West.

Miller had been incarcerated for the killing a lawman named Bobbitt in Ada, Oklahoma, when a group of vigilantes caused a power outage and then broke Miller out of jail to kill him. Professional to the last, Miller didn't beg

for mercy but instead made a hasty last will in the form of oral instructions to various persons, dressed in his best suit of clothes and went off to meet his fate. Some claim that in his last moments he confessed to the killing of Garrett, but this would be out of character for the hardened hit man. Instead, he volunteered to be hung first while his *compadres* cried and begged for mercy. Miller merely said, "You've got a job to do. Why don't you get to it."

And so they did.

What Happened to Jesse Wayne Brazel?

As the killer of the killer of Billy the Kid, Jesse Wayne Brazel's name also went down in infamy in the annals of the Old West. Unlike most men who shot a famous lawman or desperado, Brazel never went around bragging about putting a bullet in Garrett, though many say he never denied it either. One of the only people Wayne allegedly told differently was J.R. Galusha in Lordsburg, New Mexico. "I didn't kill Pat Garrett. I just took the rap for Jim Miller," he told him. Roswell resident Ernest Houghton Mathews said that Brazel said something similar to another unnamed resident of Roswell.

Whatever the case, Brazel, like Garrett and the Kid, was the subject of many pulp articles, the pulpiest being Lee Miller's *Real West* article "He Killed Pat Garrett." The article is full of tall tales. It states, for one, that he shot Garrett three more times after his body hit the ground and then alleges that he buried the gun used to kill Garrett with Pat himself. "He took to drinking and there were those who said at nights he would go to the grave of Pat Garrett and cry like a baby," is another false allegation made in the article.

Ironically, though the confessed killer of Garrett, Brazel is today the one least suspected of the crime. Even many of Brazel's contemporaries didn't believe that he was capable of such an act. Bert Judia, W.W. Cox's trusted foreman and Wayne's boss, was among those who didn't believe Brazel shot Garrett. "Whoever did so was a much better marksman than Wayne, and the killer was unhampered by a horse that went loco when a gun was fired." The horse, Loco, that Judia is referring to is the same horse that once belonged to the outlaw Reed and that Garrett's deputy shot on the Cox ranch. If this is true, that means Brazel was riding the very man's horse whose killing supposedly sparked the feud between Garrett and Cox.

"This horse must have been powder burned at some time, for he was deathly afraid of anything connected with firearms." Bert Judia, the

foreman, told Eve Ball.[76] In other words, according to Judia, there was no way that Brazel could've fired a shot on Loco, as once he did he would've been immediately bucked off.

Disputing this Loco story is Jack Carter, who knew Brazel, and says he distinctly recalls Brazel telling him the horse's name was Oso. Carter says he also asked Brazel's brother Rothmer Brazel, who says Oso was so named because O.S.O. was his brand. "He was not gun shy the least bit," Rothmer said of the horse.[77] Carter further states that Brazel told him that he killed Garrett himself and took the fall for no one. According to Brazel, he and Print Rhode bought the goats cheap, and he leased the land under a lease drawn up by A.B. Fall under Garrett fair and square.

Oddly, Brazel didn't seem to care for goats anymore after the killing and turned his interests to cattle instead. Coincidentally, years later, Brazel bought a ranch adjacent to the Tom Powers ranch in Arizona, near Brazel's Lazy S Ranch near Lordsburg. Eventually, a dispute rose between the two enemies regarding Powers's cattle wandering onto Brazel's land. Brazel threatened Powers, and Powers rode to the justice of the peace requesting a warrant for Wayne's arrest.

In September 1910, Brazel married Olive Boyd and gave birth to a son in 1911. Olive died, and baby Jess was left to be raised by his grandmother while Wayne wandered off. It is around this point that Wayne mysteriously disappeared from the history books. To fill that void exist the wild speculations of the old-timers. Some say Brazel headed north for Canada and disappeared. Some reports have Brazel killed in a drunken brawl in Texas, and others say he died of a heart attack not long after the Garrett trial.

Lawman "Buster" Brown claimed that Wayne got into some trouble in Nebraska and so moved to Arizona under an assumed name and died there in 1950. But this being Wayne Brazel, killer of Pat Garrett, surely a more glamorous fate awaited him.

The most interesting conjecture says he went to South America and joined up with Butch Cassidy's gang using the name of Dey. "It is said when the man, Dey was killed in Bolivia, the reports stated that Dey was an American named Brazel," wrote Carl Breihan in one of his pulp articles.[78] Actually, Breihan seems to have the story mixed up with a version of the purported truth. The man Dey was more likely a member of Butch Cassidy's gang when he sought refuge in South America. Dey collaborated with Butch and Sundance in a robbery in March 1906 at the bank of Mercedes in Argentina, where they stole $20,000. Dey was later said to have killed Brazel, who had made his way to South America. How or why he killed him is unknown, as is the story's exact origin.

ANOTHER BRAZEL CONSPIRACY

It would seem that conspiracy, whether real or imagined, runs in the Brazel family. Wayne is believed to be related to Mack Brazel, a Corona rancher who in 1947 found flying saucer debris on the J.B. Foster Ranch. Poor Mack was subsequently sequestered by the U.S. government, and some say was forced to cooperate in covering up the UFO incident by claiming that what he really found was just a weather balloon. When interviewed by William L. Moore for his book The Roswell Incident, *Loraine Ferguson, Mack's sister living in Capitan, informed Moore that Wayne Brazel was her father's first cousin.*

TALES OF THE GARRETT CONSPIRACY GROW

Picking up the Garrett investigation many years later was Robert N. Mullin, who as a boy used to follow Garrett around El Paso in awe. Mulin wrote in his article "The Key to the Mystery of Pat Garrett," "In my opinion the truth may never be known until and unless comes to light a true copy of the report made by Frederick Fornoff, Captain of New Mexico's Territorial Mounted Police, whose investigations began at the scene of the killing even before the victim was buried."

This report was said to contain new and startling information differing from the official reports. Mysteriously, this report was never utilized at Brazel's trial. If it had, things may have turned out differently. Diligently searching for the missing report, Mulin learned that James Hervey had it all the time, though he chose not to divulge its entire contents (which still remain a mystery) in his posthumously published *True West* article. Even what was revealed in the article was considered so scandalous that Hervey stipulated it could not be published until a full eight years after his death, which it was in 1961.

Mulin did learn that a Judge Brice, a former partner of Hervey's in Roswell, had Fornoff's full report. Brice passed away in 1964, and Mulin learned that his papers had all since been destroyed in accordance to his wishes. The judge had felt that if certain papers were made public a vicious scandal would ensue. Initially, the papers were left in a back alley to be hauled to the dump, only Morris P. Frederick, an employee of Glover's Packing Plant, picked them up out of curiosity. When Brice's heirs learned of this they

FRIDAY, NOVEMBER 12, 1943, ROSWELL, NEW MEXICO

Harkey Revives Story That Miller Killed Pat Garrett and Escaped

Did Jim Miller kill Pat Garrett?

D. R. Harkey of Carlsbad, who lived a colorful life as a peace officer in West Texas and Southeastern New Mexico before some of us were born, made it plain to an attentive audience Wednesday night that there is a strong reason to believe that it was Miller who did the slaying, a few miles west of Organ Gap, a few years ago. This belief grows out of the presence of Miller, with a terribly abused horse, at the ranch home of a friend between Kenna and Portales, the day after the slaying. Establishing an alibi was ever one of the main jobs for Miller, and by the power of deduction it might well have been that he was the slayer in this case. The exact truth will never be known for it was not long after this that Miller was lynched at Adah, Okla.

It was plain that Judge C. R. Brice, who acted as interlocutor for Harkey at the most remarkable roll-back at the Roswell Museum Wednesday night, does not consider the possibility of Miller's blood guilt as idle. The supreme court justice drew deeply upon his own memory as to the life and character of Miller, "who would kill anybody for $55.00, whose list of victims were only partially identified, and who differed from nearly all of the early day killers in that he did not drink, smoke or use rough language."

It was Mr. Harkey's party, Judge Brice simply acting as interlocutor, asking questions prompted by his long knowledge of and friendship for the Carlsbad man, which were answered in his own language for more than two hours. Altogether it was a most absorbing recital, not bothered by continuity, but all of it directly connected with the stirring border events of the six-shooter days.

Major Maurice Fulton opened the ball by the expression of the gratitude of the Museum for the continued loyal support of a group of citizens led by Judge Brice, to Mr. Harkey for his presence, and the selected group of old-timers who hung on his words for those two hours.

Among the chapters of the trail of violence, sometimes outlined by blood, were the following story periods:

Mr. Harkey was one of thirteen children.

The family lived not far from San Saba, Texas.

Three of the boys died violent deaths, two of them in the Pan-

handle at the same house.

Indians added to the dangers from bad men in those days.

His first job of frontiering was driving a wagon, at the age of 13 to the Panhandle to bring back the body of one of the brothers for decent interment at home, the trip being across trackless prairies, with the red and white menaces lined up along the way, accompanied by another boy a year or two older.

The parents died in 1869, after which the children just grew up as frontier individuals.

He became a peace officer when he was 16, and through the following years established the reputation of being the most shot at of any man on the border, though hit but once, and then by a bullet from the smoking gun of a woman, daughter of one of the hard men faced with the penalty of the law, whom Mr. Harkey came to arrest.

With dozens of gun fights, the impression was steadily carried that if he ever killed a man he didn't know it. He seemed to rely mostly upon cold nerve to carry him through, with the implication that he would shoot to kill if he had to.

Many times ambushed, the worst scare he had was when he was waylaid on Dark Canyon wells road, shot at several times and beat the bullets into Carlsbad.

He came to Carlsbad in 1890.

His first big job was reducing the outlaw wet townlet just south of Carlsbad, which was mainly done by snaking the worst of the motley crew over to Socorro on an Edmund act charge, sixteen of them in one bunch, whence eight of them were taken to the penitentiary. That broke the back of Phoenix, although bad blood persisted for some years.

Across the screen of the old man's memory flashed pictures of desperate Tom Ross, George High, Pitts and Yeager, bank robbers, Wayne Brazel, W. W. Gatewood, Cicero Stewart, U. S. Bateman, John Pollock, the battle at Organ Gap, Seminole, and so on, proving clearly the marvelous memory of the man, now a little wobbly as to dates, but calling up with positive sharpness the days when it was hardly more than fairly safe to be a peace officer. Judge Brice added to the procession across the screen by bringing out the airplane trip of Tom Ross from Texas, after escape from Texas, after escape from the penitentiary to Hope, with the intention of killing Judge Brice because of a pen sentence in this state.

tracked Frederick down and saw to it that all the papers, including the invaluable Fornoff report, were burned.

Cecil Bonney had occasion to speak with Brice in his office before he died, and he told Bonney he was certain Miller did the killing, if that's any indication as to what confirmation of certain theories that the papers might have held.

Naturally, Brazel and Miller aren't the only ones speculated to have done the killing. The name of Felix Jones, another professional killer, is also thrown into the pot, but his involvement is unlikely. Bill Isaacs speculated that Carl Adamson had done the shooting and used Brazel's pistol to do so. Many years later, Isaacs shared his theory with Jarvis, who also came to believe Adamson had done it.

Another story says Print Rhode killed Garrett, beating Miller, who was already contracted to do the job. This information came from none other than Oliver Lee Jr. to C.L. Sonnichsen in 1954.[79] Yet another legend says there was no pre-planned conspiracy with Brazel. Rather, Cox burst up from a sand dune to shoot Garrett in cold blood. Brazel,

terrified for his good friend's well-being, said that he would confess to the killing and say it was self-defense because he stood a better chance with a jury.[80]

There was only one man missing from this list of would-be assassins: Billy the Kid.

THE KID KILLS GARRETT!

Considering the rumors that Billy the Kid was alive and well and living in Mexico in the early 1900s, the period in which Garrett was assassinated, it should come as no surprise that the Kid eventually got in on the killing, too. "The Mysterious Death of Pat Garrett" for *New Mexico Magazine* in 1957 details a theory put forth by an unnamed friend of the author, Margaret Page Hood. This old-timer, as he is referred to, was a former newspaper editor from the Mesilla Valley. As this editor came by her office to visit her and talk drifted to the Kid and Pat Garrett, the old-timer postulated an interesting theory involving Garrett's death that revolved around Carl Adamson's mysterious stock of Mexican cattle he wished to purchase Garrett's land for. To Hood, he said:

> *I've got another idea. Billy the Kid always vowed during the years that he was a hunted man that it would be Pat or him. With all his faults Billy had a good memory. There was a story went the rounds at the time of the Kid's shooting that Pat hadn't killed him, only wounded him. Quite a few people believed Billy's friends had spirited him away to Mexico, and buried a dummy in the coffin. Mexico! That was where the mythical cattle were supposed to come from. Adamson and Miller had been in Mexico. Get the connection?*

"You think Adamson or Miller might have been the Kid in disguise?" Hood asked.

"No, Pat'd have recognized the Kid if he'd grown a set of whiskers down to his knees and worn blinders. But there was nothing to hinder Adamson and Miller from getting acquainted with the Kid on the other side of the Rio Grande, was there?"

"You think Billy might have planned the whole thing to revenge himself on Pat?"

The old editor winked, "*Quien sabe,* as *paisanos* say, *quien sabe!*"

"Supposin'" on the part of the old-timers had made for quite a few good tales on Billy and Pat over the years, but this one may well take the cake. Almost certainly this old-timer was in fact Allen Papen, the editor of the paper in Las Cruces at the time of Garrett's death. Papen spouts off quotes similar to the unnamed "old-timer" in another article by Margaret Page Hood, "Old Timers Throw New Light on the Death of Pat Garrett." In the article Papen says, "For one thing, Adamson turned out to be a killer himself. For another, no cattle ever did come over from Mexico for those two men. That was the last anyone around here ever heard of their two thousand head or any question of leasing land or buying goats." Papen also remarked, "The murder of Pat Garrett was big news and for a couple of days I was as busy as any editor on a big town paper."

Robert N. Mullin said that on the streets of El Paso, the "whispered accounts ranged from the plausible to the incredible." Perhaps this Billy rumor was one of them, though surely the press would have picked it up and run with it. Likely, it was all the speculation of Papen. Another interesting nugget in this bizarre milieu appears in *An Outlaw Called Kidd*, wherein author Zeke Castro alleges that Carl Adamson later married the daughter of Joseph Clements after Garrett's shooting. According to Castro's book, a surviving Billy the Kid was living on Clements's ranch in the 1950s.

FRIENDS AND FOES OF PAT GARRETT: KILLIN' JIM MILLER

As it turns out, Garrett's greatest enemy may well have been a man whom he had never laid eyes on: Killin' Jim Miller. However, some do claim that Garrett did know Miller from his days in Texas. John Milton Scanland wrote, "Miller and Garrett had known each other for several years, Miller being marshal in Pecos City when Garrett was sheriff of Lincoln County."[81] Others say Garrett surely had to be aware of Miller's reputation, even if they hadn't met before, but was so desperate to sell his land he decided to take a risk.

Today, Miller is typically considered the prime suspect in the killing. Born in 1866, Killer Miller began his career at the age of eight when he murdered his grandparents, or so legend says.[82] Miller kept his skills in the family for his next victim: his argumentative brother-in-law whom he shot in the head with a shotgun while he was asleep. Miller's conviction was subsequently overturned on a technicality, and so he continued his reign

with the six-shooter as a town marshal in Pecos, Texas, where he would often gun down "escaping prisoners."

Miller eventually married Sallie Clements, sister of Mannen Clements, and it was rumored that this family connection is what eventually led to Miller being hired to kill Garrett. In any case, Miller's skills with the gun didn't go unnoticed by those who had money, and Miller was soon being paid for his hobby as an assassin, charging $150 a head. Regarding Garrett, legend has it that Miller once told a man that Pat Garrett was the closest call he ever had. This tale was told in a written letter by none other than Judge Brice of Roswell, who has some curious connections to the killing. It was told to Brice by Tom Coggins, who knew Miller: "Pat had a gun down in the bottom of the buggy by his foot and got it and almost killed Miller. He said Miller said it was the closest call he ever had in any of his killings." Coggins also claimed a rancher named May hired Miller to do the killing. It is also rumored that when the noose tightened around Miller's neck before he was to be hanged he confessed to killing Garrett, but the man, Walter Gayne, who actually strung him up refutes this.

There also exists a statement from a man who says he asked Miller about killing Garrett. Miller's response to him was, "There was no money offered. Why should I kill him?"[83]

On the contrary though, there were said to be sightings of Miller in and around the Cruces area on the day of the shooting; one of the sightings was by none other than the man bringing Garrett's large coffin into town. He said he saw Miller conversing with one of Garrett's known enemies. In his **Fabulous Frontier**, William Keleher relates another sighting: "In White Oaks [Miller] attracted particular attention because he was dressed pretty much like a preacher, wearing, it was recalled, a Prince Albert coat and a black bowtie as part of his outfit. Miller had been seen at the Park Hotel and at one of the banks in Las Cruces on the day that Pat Garrett was killed; and he had been seen in and around El Paso for several days."

Considering that Miller and Adamson's Mexican cattle never materialized anywhere, the argument that Miller was in on the conspiracy to kill Garrett is a solid one.

THE GUNS OF PAT GARRETT: 1909-34

It was a strange turn of events that the very gun that was taken from his gang,
was later used to end his life.
—Pat Garrett, on the gun he used to kill the Kid

On December 21, 1880, Billy the Kid was holed up in Stinking Springs along with Charlie Bowdre, Dave Rudabaugh and Billie Wilson, while Pat Garrett and his posse waited outside. Little did the Kid know that the Frontier Colt belonging to his pal Billie Wilson would one day be used by his "pal" Pat to kill him. Garrett was intrigued by Wilson's Colt Frontier six-shooter, which fired the same ammunition as Wilson's Winchester rifle. Garrett fancied them, and so he kept them. Specifically, the revolver was a .44-40 Frontier Colt (serial number 55093) with a seven-and-one-half-inch barrel and "plain wooden grips" made in 1880.[84] Therefore, it was practically brand new when he used it several months later to kill the Kid. Or so history states, but even this coincidental story wasn't enough for some old-timers, who insisted that the gun that killed the Kid needed a more elaborate history. The first came courtesy of the July 19, 1881 *Las Vegas Optic*, which claimed that the gun that killed the Kid came from Houghton's Hardware store in Las Vegas. "This is not an advertisement, but an interesting fact."

The most interesting story to surface stated that the revolver used to kill Billy had belonged to Wild Bill Hickok, who died clutching that very gun in his hands when he was shot and killed in Deadwood, South Dakota. This tall tale came from Fred E. Sutton, a deputy U.S. marshal who claimed to

know Garrett so well that Garrett gave him the actual gun. In *Hands Up!*, a biography of sorts on Sutton, he claims, "The gun that was in Wild Bill's right hand then is in my collection of firearms. He had carried it only two years before his death, but there are fourteen notches cut by him in its stock. This six-shooter was given to Pat Garrett by Wild Bill's sister, the wife of a farmer in northern Kansas. Pat carried it for several years and with it killed Billy the Kid."

Sutton says Garrett specifically told him about the night of the shooting, saying, "I had a rifle in my hand, and before I stepped up on the porch I drew my six-shooter, the same weapon with which Wild Bill Hickok had killed so many, and which he was wearing when he was killed in Deadwood."[85] Sutton reprints a letter from Pat Garrett with further details on the gun, stating that it was a Colt .45 No. 139345 with "the dog filed off" and engraved with Wild Bill's name. The letter also reads, "This is the gun I put your friend Billie the Kid, out of business with at the Pete Maxwell ranch on July 14, 1882." This is quite humorous as Billy the Kid was killed on July 14, 1881. It's most likely this story was an elaboration by Sutton, for if the gun once held by Wild Bill Hickok was the one that killed the Kid then it really is a small world.[86]

In *Guns* magazine, author E.B. Mann wrote of this remarkable coincidence:

> *What a prize for the collector of "celebrity" guns: a gun connected with not one but three of the West's great figures—Hickok, Garrett, and Billy the Kid!...But there are several discrepancies, to state it mildly. Hickok's sidearms, according to such thorough researchers as Joseph G. Rosa and others, "...were either cap-and-ball Armies, or Springfield Armory conversions, or Richards-Mason conversions to the rim or center fire cartridge...There is little likelihood that Hickok used a Peacemaker."*

Mann goes on to inform the reader that the serial number given by Garett in the letter to Sutton was for a revolver made in 1891, a good ten years after he killed the Kid and fifteen years before Hickok died. He concluded the matter by stating, "Well, Garrett was a practical joker; perhaps this gun (if he ever owned it) and the letter (if he wrote it) are products of his wry humor."

The always reliable (for a good yarn that is) Carl Breihan had some details on the Hickok connection he shared in a *Real West* article. In it he said that wealthy Deadwood resident Samuel Collins took note of Wild Bill Hickok's contempt for Billy the Kid. This hatred was never elaborated on, but supposedly Collins then bet a miner named Bert Baker $5,000 that

"Hickok would emerge the winner in any duel to the death with Billy Bonney." Specifically, the terms of the bet, "notarized" by the bartender of the Criterion Saloon, stated that Hickok's gun would kill Billy the Kid. Years later, Collins read an account of the Kid's death that stated, "Pat Garrett was carrying a lucky gun the night he got the Kid. It was the same gun carried by Wild Bill Hickok until his murder and was later given to Garrett by Hickok's sister in Kansas." Collins must have waited a very long time to read this and "win his bet" for *Hands Up!* wasn't published until the 1920s, assuming that was where he read it. Naturally, this myth was incredibly popular throughout the 1940s to '60s, when semi-factual pulp western magazines and books were rampant. Even the massive *The Book of the West* reprints the story, this time recounted by someone named Lucian Cary.

In reality, Garrett stated many times that the gun in question was the one formerly owned by Billie Wilson. Garrett loaned this gun (some say for money) to his good friend Tom Powers at his Coney Island Saloon. Powers displayed the guns prominently behind the main bar. If they carried a tag with the owners' names attached, then they naturally belonged to the owner. If they were tag-less, they belonged to Powers. It is debated whether Garrett's gun was tagged or untagged.

In the words of *Star Wars*' Obi Wan Kenobi, the Coney Island could have been described as a "wretched hive of scum and villainy." Billy the Kid could perhaps rest easy that the genuine article that killed him was displayed in such a location. Alongside the gun that killed the Kid were also guns and rifles belonging to the likes of Apache chief Victorio, Pancho Villa and John Wesley Hardin, to name a few.

In a signed statement dated April 16, 1906, Garrett wrote:

> *This Colt 44 pistol is the one I used to end the life of William Bonney…The gun carries the serial number 55093. I took the gun from one of the "Kid's" gang at the battle of "Stinking Springs." This gun and the 1873 Winchester bearing the serial number 47629, were taken after the above-mentioned battle and retained by me. Both guns were new and my position as Sheriff of Lincoln County, allowed me to take and use any equipment that I so desired.*
>
> *The story of the death of the "Kid" is very well known and does not need retelling again: however it should be known that the "Kid" was killed that night and does not live in Mexico, as some have stated. I used this Colt 44 to end his depredations in the county.*

It was a strange turn of events that the very gun that was taken from his gang, was later used to end his life.

These guns were of the same caliber and were very handy, because only one kind of ammunition had to be carried.

These guns are my prize souvenirs, because of their association with the Lincoln days and because I carried them through many trying times. During my life, I have owned many guns of all types and calibers, but these two have been my favorites and the ones that I relied upon to protect and defend the people whom I have served.

I have been asked to exhibit these guns many times, but I was always fearful that they might be lost or stolen. Consent has been given to my friend Tom Powers to display them as he so pleases and to retain them until such time as I recuest [sic] their return.

<div align="right">

Signed, P.F. Garrett

</div>

And so Garrett's prized possessions hung in the gun gallery of the Coney Island, even after Pat left El Paso and lost his life altogether. In later years, after the Coney Island had closed down due to the Prohibition Act, Powers retained the guns. When Mrs. Garrett asked that they be returned, he claimed he had purchased the guns from Pat legally and refused. Apolinaria wouldn't get a shot at reclaiming the guns until Powers had died from an injury from an attempted suicide on January 1, 1931. Apolinaria filed suit in 1933 against Dr. J.B. Brady, administrator of the Powers estate. Meanwhile, Powers's collection of guns, sans Garrett's, went at auction for $200 to a Mr. J.W. Johnson.

As the lawsuit progressed, even the gun that killed the Kid was enough to stir up a media circus. In her article "The Gun That Killed Billy the Kid," Mary'n Rosson stated that the ensuing trial brought forth "at least fifty statements from people claiming to have the gun that killed Billy the Kid." The author continues:

Among these was Sheriff Jesus Baca of Santa Fe who stated that Garrett did not have the gun that shot Billy. Baca vowed he was the owner of the original gun, a pearl-handled Frontier Colt six-shooter of .44-40 caliber. This claim was laughed off by old timers who stated no lawman would carry a pearl-handled pistol. It was not only fragile, it had several superstitions attached to it. One Texas Ranger stated, "Every dead man I ever saw carried a pearl handled-pistol."

Another claimant was a seventy-year old Mexican legislator who said he witnessed Billy's killing. He helped carry Billy's body away. He also stated

the death weapon was a .41 caliber gun of unusual size and there was no mistaking that gun.

Former governor Curry himself even weighed in on the trial, attesting to the authenticity of Power's gun as did a former employee of Powers, Ed Warren. An April 23, 1933 letter written by Warren states:

My name is Ed Warren, I am a long time resident of El Paso. I have worked for Mr. Tom Powers, off and on, for many years. I knew Mr. Pat Garrett very well, as he came into the "Coney Island" many times while I worked there. I will relate the story of two times when Mr. Garrett came into the "Coney Island" and made transactions involving guns with Mr. Powers.

Two separate times, Mr. Garrett came into the "Coney Island" and left guns for Mr. Powers to display in his collection.

The first time, about 1906, Mr. Garrett [brought] in two guns; These guns were a gold plated .41 Colt and a .44 Winchester rifle. I have examined the guns in the Powers estate and can attest, beyond a shadow of a doubt, that they are the ones bearing the numbers 138671 on the Colt and 47629 on the Winchester.

On another visit, Mr. Garrett brought in a .44 Colt pistol and left it for display…At the time of this second visit, Mr. Powers gave Mr. Garrett some money and took the exhibit tags from the golden Soltand and Winchester rifle; therefore I am sure these guns were sold to Mr. Powers. As for the big Colt .44; I am not truly sure that this was sold to Mr. Powers, but I assumed that Mr. Powers had purchased it, as he took off the exhibit tag later on.

The gun referred to as the "Garrett Gun" is beyond a doubt the Colt .44 number 55093. I listened to Mr. Garrett relate how he killed "the Kid" with this gun. Mr. Garrett said that he had taken the .44 Colt and the .44 Winchester from an outlaw named Billy Winston or Wilson at a shoot-out called "Stinking Springs." Later, he used the same gun (55093) to kill the leader of the "Stinking Springs" battle; Billy the Kid. Mr. Winston came thru this town once and identified the two guns once for Mr. Garrett and Mr. Powers.

The golden Colt .41 was gived [sic] to Mr. Garrett by some friends at the Customs House in 1902. This fact is attested to by the fact that Mr. Garrett said this on numerous visits.

ANOTHER GUN OF GARRETT'S

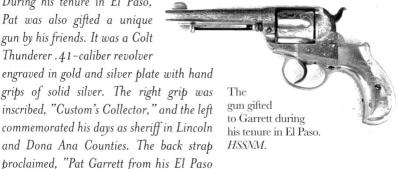

During his tenure in El Paso, Pat was also gifted a unique gun by his friends. It was a Colt Thunderer .41-caliber revolver engraved in gold and silver plate with hand grips of solid silver. The right grip was inscribed, "Custom's Collector," and the left commemorated his days as sheriff in Lincoln and Dona Ana Counties. The back strap proclaimed, "Pat Garrett from his El Paso Friends." This, too, was believed to be one of the guns Garrett loaned to Powers. It is now on display at the Ruidoso River Museum and Fox Cave.

The gun gifted to Garrett during his tenure in El Paso. *HSSNM.*

The Eighth Court of Appeals ruled that the gun rightfully belonged to Mrs. Garrett, then seventy-three years old. A small ceremony was held in which a U.S. attorney general handed over the gun to Apolinaria. An October 06, 1933 *El Paso Times* article stated, "Mrs. Garrett is ill, but said she would be able to stand on the front porch of her Las Cruces home and receive the gun." She died two years later in Las Cruces, and Jarvis inherited the relic. For many years, Jarvis kept the gun in a safety deposit box in the vault of an Albuquerque bank and would take it out occasionally to show to writers and researchers. He later sold the gun to a collector in Austin for an undisclosed amount.

In the late 1960s, a commemorative edition Pat Garrett Model Colt Single Action revolver was made as part of Colt's Firearm's Lawman Series. Jarvis Garrett was never a fan of marketing/exploiting his father's name and once filed a lawsuit after an El Paso jean company called Farah put the image of his mustachioed father on a pair of children's jeans.

But of course, this being the story of the gun that killed Billy the Kid, it can't be wrapped up too concisely. According to Tom Powers's daughter, Tommy Powers Stamper,[87] the gun given to the Garrett heirs was only a replica, and the Powers family was still in possession of the real gun.[88]

FRIENDS AND FOES OF PAT GARRETT: TOM POWERS

Michael Thomas Powers was the second youngest of twenty-four children,[89] born just one week after his mother arrived in New York from Ireland on September 18, 1860. The family's name was originally O'Powers, but they dropped the "O" upon arriving in America. The family soon moved to Wisconsin, where young Tommy often witnessed his father beating his mother ("an old Irish custom"), and when he got old enough to do something about it, he "beat the hell out of his father" and then left for the West. Powers was seventeen years old, and on his way heading southwest he lived with several different Indian tribes—among these the Sioux and the Blackfeet—who made him a "blood brother." Eventually, Powers landed in New Mexico and had a brief encounter with Billy the Kid and later made his way to Texas, where he married (and later divorced) a rich widow. In 1886, Powers got into a shootout in self-defense wherein he killed a man and was then tried and acquitted for murder. Eventually, he married Kathleen Pipkin in 1900 and had a daughter whom he named Tommy. According to Tommy, her father was a sheriff in a town near Austin, and it was Powers's first wife who got him into the saloon business. Powers had a rough reputation around El Paso, known equally for his skills with a gun and his fists. One day a man tipped his hat a little too enthusiastically to Mrs. Powers, and when she informed the man who her husband was he reportedly took off running.

At some point, Powers lost an eye and due to this was nicknamed "One Eyed Riley." He befriended Pat Garrett when he began frequenting the Coney Island. Garrett so admired Powers that he named his youngest son Jarvis Powers Garrett. However, Powers eventually became the "patsy" to get Patsy Garrett out of office in 1905, when he appeared in a photograph next to President Theodore Roosevelt as Garrett's guest. As Powers was considered a scalawag, his posing with the president was considered a major faux pas. In a true twist of fate, Powers reconnected with Roosevelt years later and gifted the president a pet bear cub named Teddy, thus leading to the birth of the term teddy bear.[90]

In 1918, Powers was forced to close the Coney Island, which became a barbershop, due to the Prohibition Act. Powers eventually ran for chief of police in El Paso but was defeated by the more morally upright citizens of the town who recalled his saloon days. In any case, Powers did serve as a deputy U.S. marshal, special deputy sheriff and peace and truant officer.

For no apparent reason, while sitting in his rocking chair on the front porch of his El Paso home, Powers drew a pistol from under his blanket and shot himself through the chest, aiming for his heart. This was on December 13, 1930, but Powers missed his heart and, as such, clung to life until New Year's Day, when he finally died.

AFTERWORD

During his years as a rancher, sometime after he had killed the Kid, one of Garrett's hired hands, Jim Mullens, asked him why he gave him a raise seemingly for no clear reason. Garrett replied, "Because you are one of the very few men that ever worked for me who didn't ask a lot of damned fool questions about Billy the Kid and the Lincoln County War." Whether he liked it or not, killing the Kid is what Garrett will always be remembered for. But as readers of this book now know, he did far more than that, chief among them having a hand in the creation of Capitan, New Mexico, making Roswell the seat of Chaves County and also irrigating the Pecos Valley.

Though there are no Pat Garrett museums and there is a scarcity of Garrett merchandise in comparison to the Kid, Garrett may well be the savior of New Mexico tourism. Had he not shot the Kid, the outlaw could have never become such a money-making icon for the state (and let us not forget Garrett's connections to Capitan's Smokey Bear and the Roswell Incident, tenuous though they may be). And yet he's still treated as a villain by many.

Justice was finally served in 2012, when Garrett received his first formal memorial outside of his grave in Las Cruces. Artist Robert Summers, who had previously done a bronze statue of John Chisum for Roswell, was commissioned to do a large bronze statue of Garrett. It was dedicated on March 31, 2012, in front of the Chaves County Courthouse in Roswell to much fanfare with one of the Garrett grandchildren, J.P.

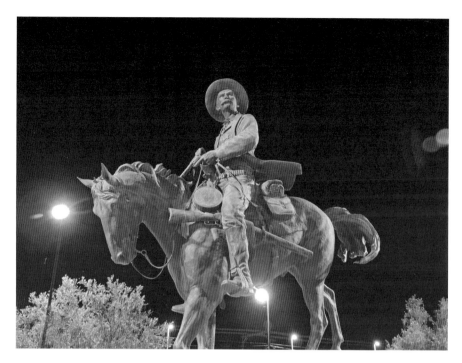

A bronze statue of Pat Garrett in front of the current-day Chaves County Courthouse. *Photograph by Philip Nelson.*

Garrett, in attendance among others. Though long overdue, Garrett finally received the recognition that he deserved in his old "hometown" of Roswell, New Mexico.

NOTES

Introduction

1. Metz, "Truth and Tall Tales," 54.
2. Conversely, in western magazines such as *Frontier Times*, *Golden West*, *Old West* and *True West*, Garrett was just as popular as the Kid, and it's quite possible they wrote more articles on him than Billy.
3. *Grant County Herald*, "A Talk with Pat Garrett," special correspondence of the *Globe Democrat*, August 20, 1881.
4. Sonnichsen, "Pat Garrett's Last Ride."
5. Ball, *Ma'am Jones*, 178.
6. Baliert and Breihan, *Billy the Kid*, 131.
7. Scanland, "The Man of the Hour Pat Garrett" in *Life of Pat F. Garrett*, 18.
8. Shinkle, *Reminiscences of Roswell Pioneers*. Though the cuss word is omitted in most recollections of the story, Morgan Nelson says it was indeed "son of a bitch."
9. Kadlec, *They "Knew" Billy the Kid*, 122.
10. Reissued by Sunstone Press in later years as *Sheriff Pat Garrett's Last Days*.
11. Keleher, *Fabulous Frontier*.

Chapter 1

12. There is a great deal of debate as to whether Garrett's full name was Patrick Floyd Jarvis Garrett.
13. Breihan, "Saga of Patrick Floyd Garrett," 26.
14. Pat Garrett said he was a colonel in the Confederate army, but it appears more likely he never served in the Civil War due to poor health.
15. Breihan, "Saga of Patrick Floyd Garrett." "Although popular in Fort Sumner, many people believed Pat had been just two steps ahead of a posse of Rangers before crossing the State Border, due to his unconventional notions regarding cattle ownership."
16. Lake, *Wyatt Earp*, 168–69.
17. It's not certain if in fact it was Garrett's first killing.
18. O'Connor, *Pat Garrett*, 18.
19. Haley, interview with Frank Lloyd, 1927.
20. Ball, "Real Pat Garrett."
21. Metz, *Pat Garrett*, 39.
22. Garrett was so tall that he had difficulty finding pants that would fit him. Sometimes he had to tie an extra covering of buffalo hide to his trousers.
23. Ball and Judia, "Real Pat Garrett."
24. Kadlec, *They "Knew" Billy the Kid*, 81.
25. Jim Mullens asserts that quiet, enigmatic Garrett was also known as "the Mystery Man."
26. Keleher, *Fabulous Frontier*.

Chapter 2

27. The Comanches had stabbed several through the neck so that they couldn't be reclaimed.
28. Dills, "Billy the Kid."
29. A folk tale of the incident, related by Carolatta Baca Brent, one of the posse member's wives, says that Billy slyly tried to pull his horse through the open door with a rope, the presumption being he would take it inside and ride out the back. Pat, being a crack shot in the tale, shoots the rope, snapping it free and frightening away the horse.
30. Spencer was a famous tough guy star of several spaghetti western comedies with Terence Hill, including the *Trinity* films.
31. This is actually unlikely, as Fort Sumner, being in San Miguel County, was out of Garrett's jurisdiction.

CHAPTER 3

32. *Roswell Daily Record*, March 4, 1931.
33. O'Connor, *Pat Garrett*, 107.
34. Sonnichsen and Morrison, *Alias Billy the Kid*, 49.
35. This conflicts with accounts that Lon Horn, of the New England Cattle Company who bought the Maxwell house, used its lumber to build a ranch at Tu-les, thirty miles away on the Old Portales Road.
36. Brent, *Complete and Factual Life*, 192.
37. Haley, interview with Bill Jones, 1927.
38. Ball, "Shelton Taylor Interview," 1951.
39. Breihan, "The Day Billy the Kid Was Killed," 40.
40. It's possible that this fanciful story is using Celsa Gutierrez as the hostage. Celsa's father's name was Jose, but her husband's name was Saval Gutierrez. This is also a good spot to note that at least one old-timer, Carolatta Baca Brent, claimed that Billy planned to "capture" Paulita Maxwell and take her to Mexico with him.

CHAPTER 4

41. Gardner, *To Hell on a Fast Horse*, 186.
42. Governor Lionel Sheldon was away in Washington, D.C., after the assassination of President Garfield.
43. Bonney, *Looking Over My Shoulder*, 72.
44. By most accounts, it didn't seem that Garrett spent much time looking over his shoulder for friends of the Kid. Though, there is a rumor he once forbade the cowboys of the Captain Brandon Kirby Ranch, of which he was foreman, from carrying guns lest one of them turn out to be a friend of the dead Kid's.
45. Rasch, "Bonney Brothers," 61.
46. It was more likely Albuquerque.
47. Bryan, *Albuquerque Remembered*, 131.
48. Conversely, in a few articles Pat is mistakenly credited with discovering Roswell's famous underground artesian water basin, which was in fact discovered by Nathan Jaffa. It is possible though that Pat suspected the presence of artesian water under the ground.
49. Before this, Garrett had also invested in the North Spring River Centre Ditch Company on October 1, 1881, with Captain J.C. Lea, Barney Mason and Ella Lea Calfee. Author Kenneth Osthimer

speculates that Garrett wrote *Authentic Life* primarily to raise money to invest in the company.

50. For those no doubt wondering, Campbell Fountain was no relation to A.J. Fountain.

51. Garrett for certain returned to Roswell in 1893, as a Chaves County grand jury indictment of Charles Ballard exists citing him for keeping a gambling table without a license. Among those present were Pat Garrett and his old boss James Cree.

52. Supposedly early drafts of the manuscript existed at one point but were lost.

CHAPTER 5

53. Thornton was said to be a big Santa Fe Ring boss who always attended trials at which Santa Fe Ring business was at stake, including the sentencing of Billy the Kid at Mesilla.

54. Sonnichsen, *Tularosa*, 153.

55. Though Garrett didn't know it, Deputy Espalin caused him a good deal of misfortune. First of all, he was secretly sympathetic to Lee and more or less warned him that Garrett would be coming for him at Wildy Well. Second was the shooting of an outlaw known as Reed, which Garrett may have paid the price for in the form of a feud between him and W.W. Cox.

56. Lee said later on that he took aim at Garrett's head and shot at him; after Garrett ducked down he was gleefully excited because he thought he had killed him.

57. Williams, "Mystery in the White Sands."

58. Metz, *Pat Garrett*, 213.

59. O'Connor, *Pat Garrett*, 196.

60. The swooning press even claimed that Lee spoke Greek and Latin.

61. Lofton, "Who Killed Judge Fountain?"

CHAPTER 6

62. Roosevelt made Bat Masterson a federal marshal in New York.

63. Garrett is referring to writer Eugene Manlove Rhodes, who had a speech impediment. Perhaps Fall teased him about it and incurred the smaller man's wrath?

64. Nelson and Weisner, "Don't Offend the Priests of Amun," 2.

Chapter 7

65. Pattic and Oliver, "Footloose and Fancy Free."

66. O'Connor, *Pat Garrett*, 215.

67. Other than the suspected killer Olive Lee being Cox's brother-in-law, there is no reason why Cox would care that Garrett reopened the case.

68. Other sources say a collection was taken up by the men together to pay Miller an amount of either $1,500, $5,000 or $10,000.

69. Strangely, on the same night Pat Garrett had prowlers on his ranch, Bert Judia claims that there were prowlers on the Cox ranch.

70. Sonnichsen, "Pat Garrett's Last Ride."

71. Scanland, *Life of Pat F. Garrett*.

72. Ibid. Scanland used many newspaper articles in his text but without citing the exact editions.

Chapter 8

73. Some even whispered that Powers himself killed him.

74. Some speculate that Adamson really did want to buy Garrett's land for the purpose of hiding immigrants there. Mannie Clemments also had a tie to the Chinese smuggling. On the night he died, he was said to be making threats against Charles F. McClanny, who was said to be involved in the operation of smuggling Chinese, though it's not known if he was connected to Adams.

75. *Roswell Daily Record*, "Pat Garrett Killed by Ex-Roswell Man," March 5, 1908.

76. Judia also tries to claim that it was Garrett who shot Reed in the back rather than his deputy, but Judia was not actually there to witness the act one way or the other.

77. Carter, "Some Facts About Wayne Brazel."

78. Breihan, "The Day Pat Garrett Was Killed."

79. Gardner, *To Hell on a Fast Horse*, 241.

80. This theory was postulated by W.T. Moyers, a New Mexico lawyer from Colorado.

81. Scanland, *Life of Pat F. Garrett*, 5.

82. Whether he did the killing or not, said grandparents were indeed murdered.

83. Carter, "Some Facts About Wayne Brazel." This information comes from Jeff Ake, who knew Jim Miller.

CHAPTER 9

84. Metz, *Pat Garrett: Story of a Western Lawman*, 98.
85. MacDonald and Sutton, *Hands Up!*, 54.
86. Sutton was also given a gun by Bat Masterson, who jokingly carved twenty-three notches in the gun despite having killed only three men.
87. So named because Powers had no sons to name after himself.
88. Leon Metz learned this in an interview on July 10, 1968, in Virden, New Mexico.
89. You read correctly—that is not a typo.
90. One has to wonder, had Garrett never shot the Kid, would his political career have ever taken off and would Powers have ever met Roosevelt? Is it safe to surmise then that Pat Garrett and Billy the Kid are indirectly responsible for the naming of the teddy bear?

BIBLIOGRAPHY

BOOKS

Anaya, Paco. *I Buried Billy*. College Station, TX: Early West, 1991.

Bailert, Marion, and Carl Breihan. *Billy the Kid: A Date with Destiny*. Seattle, WA: Hangman Press, 1970.

Ball, Eve. *Ma'am Jones of the Pecos*. Tucson: University of Arizona Press, 1973.

Bell, Bob Boze. *The Illustrated Life and Times of Billy the Kid*. Phoenix, AZ: Tri-Star Boze, 1992, 2004.

Billy the Kid: Las Vegas Newspaper Accounts of His Career, 1880–1881. Waco, TX: W.M. Morrison Books, 1958.

Bonney, Cecil. *Looking Over My Shoulder: Seventy-five Years in the Pecos Valley*. Roswell, NM: Hall-Poorbaugh Press, 1971.

Brent, William. *The Complete and Factual Life of Billy the Kid*. New York: Frederick Fell, Inc., 1964.

Bryan, Howard. *Albuquerque Remembered*. Albuquerque: University of New Mexico Press, 2006.

————. *Wildest of the Wild West: True Tales of a Frontier Town on the Santa Fe Trail*. Santa Fe, NM: Clear Light Publishers, 1991.

Burns, Walter Noble. *The Saga of Billy the Kid*. New York: Doubleday, Doran and Company, 1929.

Burroughs, Jean. *On the Trail: The Life and Tales of "Lead Steer" Potter*. Santa Fe: Museum of New Mexico Press, 1980.

Castro, Zeke. *An Outlaw Called Kidd: The Reality of Billy the Kid*. Montgomery, AL: E-Book Time, LLC, 2012.

Cozzens, Gary. *Capitan, New Mexico: From the Coalora Coal Mines to Smokey Bear*. Charleston, SC: The History Press, 2012.

Dellinger, Harold, ed. *Billy the Kid: The Best Writings on the Infamous Outlaw*. Helena, MT: TWODOT, 2009.

Fleming, Elvis E., and Ernestine Chesser Williams. *Treasures of History II: Chaves County Vignettes*. Roswell: Historical Society for Southeast New Mexico, 1991.

Gardner, Mark Lee. *To Hell on a Fast Horse: The Untold Story of Billy the Kid and Pat Garrett*. New York: Harper, 2011.

Hendron, J.W. *The Story of Billy the Kid*. Santa Fe, NM: Rydal Press, 1948.

Hertzog, Peter. *Little Known Facts About Billy the Kid*. Santa Fe, NM: Press of the Territorian, 1964.

Kadlec, Robert F., ed. *They "Knew" Billy the Kid*. Santa Fe, NM: Ancient City Press, 1987.

Keleher, William. *The Fabulous Frontier*. Santa Fe, NM: Sunstone Press, 2008.

Klasner, Lily. *My Girlhood Among Outlaws*. Tucson: University of Arizona Press, 1988.

Lacy, Ann, and Anne Valley Fox, eds. *Frontier Stories: A New Mexico Federal Writer's Project*. Santa Fe, NM: Sunstone Press, 2010.

———. *Outlaws and Desperados: A New Mexico Federal Writer's Project*. Santa Fe, NM: Sunstone Press, 2008.

Lake, Stuart. *Wyatt Earp: Frontier Marshal*. New York: Pocket Books, 1931, 1994.

L'Aloge, Bob. *Ghosts and Mysteries of the Old West*. Las Cruces, NM: Yucca Tree Press, 1990.

MacDonald, A.B., and Fred E. Sutton. *Hands Up! Trues Stories of the Six-Gun Fighters of the Old Wild West*. New York: A.L. Burt Company, 1926.

Metz, Leon. *Pat Garrett: The Story of a Western Lawman*. Norman: University of Oklahoma Press, 1974.

Nolan, Frederick., ed. *The Billy the Kid Reader*. Norman: University of Oklahoma Press, 2007.

———. *Tascosa: Its Life and Gaudy Times*. Lubbock: Texas Tech University Press, 2007.

———. *The West of Billy the Kid*. Norman: University of Oklahoma Press, 1998.

O'Connor, Richard. *Pat Garrett: A Biography of the Famous Marshal and Killer of Billy the Kid*. New York: Curtis Books, 1960.

Otero, Miguel Antonio, Jr. *The Real Billy the Kid*. Houston, TX: Arte Publico Press, 1998.

Recko, Corey. *Murder on the White Sands: The Disappearance of Albert and Henry Fountain*. Denton: University of North Texas Press, 2007.

Scanland, John Milton. *Life of Pat F. Garrett and the Taming of the Border Outlaw*. El Paso, TX: Filter Press, 1971.

Shinkle, James D. *Reminiscences of Roswell Pioneers*. Roswell: Hall-Poorbaugh Press, 1966.

Sonnichsen, C.L. *Tularosa: Last of the Frontier West*. Albuquerque: University of New Mexico Press, 1960, 1980.

Sonnichsen, C.L., and William V. Morrison. *Alias Billy the Kid*. Albuquerque: University of New Mexico Press, 1955.

White, Owen P. *The Autobiography of a Durable Sinner*. New York: G.P. Putnam's Sons, 1942.

Wilson, John P., ed. *Pat Garrett and Billy the Kid as I Knew Them: Reminiscences of John P. Meadows*. Albuquerque: University of New Mexico Press, 2004.

Newspaper and Magazine Articles

Ball, Eve, and Burt Judia. "The Real Pat Garrett." *Frontier Times*, February–March 1964.

Breihan, Carl W. "The Day Billy the Kid Was Killed." *Real West*, December 1974.

———. "The Day Pat Garrett Was Killed." *Real West*, April 1975.

———. "The Saga of Patrick Floyd Garrett." *Golden West*, January 1968.

Carter, Jack. "Some Facts About Wayne Brazel." *Frontier Times*, June–July 1972.

Cronyn, George. "Who Really Shot Billy the Kid?" *Real West*, September 1966.

Edwards, Harold L. "Barney Mason: In the Shadow of Pat Garrett and Billy the Kid." *Old West* (Summer 1990).

Hervey, James Madison. "The Assassination of Pat Garrett." *True West*, March–April 1961.

Hood, Margaret Page. "The Mysterious Death of Pat Garrett." *New Mexico Magazine*, January 1957.

———. "Old Timers Throw New Lighting on Shooting of Pat Garrett." *New Mexico Sentinel*, April 23, 1939.

Kemp, Ben W. "Ride for Mexico, Billy!" *Frontier Times*, February–March 1980.

Lofton, Monk. "Who Killed Judge Fountain?" *True West*, March–April, 1963.

Mann, E.B. "Pat Garrett—Part One." *Guns*, March 1969.

———. "Pat Garrett—Part Two." *Guns*, April 1969.

Metz, Leon. "My Search for Pat Garrett and Billy the Kid." *True West*, August 1983.

———. "The Truth and Tall Tales of Pat Garrett." *New Mexico Magazine*, February 2008, 52–55.

Miller, Lee. "He Killed Pat Garrett." *Real West*, January 1960.

Mullin, Robert M. "The Key to the Mystery of Pat Garrett." *Los Angeles Westerners Corral*, June 1969.

Nolan, Frederick. "Here He Lies." *Western Outlaw Lawman Association* (WOLA) *Journal* (Spring 2003).

Pattic, Jane, and Kenneth Oliver. "Foot-Loose and Fancy Free." *Old West* (Winter 1969).

"Pistol That Killed Billy the Kid Will Be Returned to Garrett's Widow." *El Paso Times*, October 6, 1934.

Rasch, Phillip J. "The Bonney Brothers." *Frontier Times*, December–January 1965.

Rhodes, May D. "Frontier Mystery." *New Mexico Magazine*, May 1947.

Rosson, Mary'n. "The Gun That Killed Billy the Kid." *Old West* (Winter 1970).

Seavers, Earl. "The Untold Saga of Sheriff Pat Garrett." *Frontier West*, April 1973.

Smith, Joe Heflin. "The Tragic Life of Pat Garrett." *Real West*, July 1968.

Sonnichsen, C.L. "Pat Garrett's Last Ride." *True West*, November–December 1958.

Sonnichsen, C.L., and A.G. Carter. "Neighborhood Talk of Pat Garrett." *Old West* (Fall 1970).

Williams, Gary. "Mystery in the White Sands." *The West*, April 1965.

MANUSCRIPTS

Ball, Eve. "Shelton Taylor Interview Following a Visit with Mr. Tom Story of Phoenix, Arizona." San Patricio, NM, October 25, 1951, HSSNM, Maurice G. Fulton Lincoln County War Archival Collection A/C 20060924.

Dills, Lucius. "Billy the Kid." Unpublished, HSSNM Archives, Box One, Patterson Collection.

Haley, J. Evetts. Interview with Bill Jones. Rocky Arroyo, NM, January 13, 1927, HSSNM, Maurice G. Fulton Lincoln County War Archival Collection A/C 20060924.

———. Interview with Frank Lloyd. Tularosa, NM, August 18, 1927, HSSNM, Maurice G. Fulton Lincoln County War Archival Collection A/C 20060924.

———. Interview with Sophie Poe. Roswell, NM, April 19, 1947, HSSNM, Maurice G. Fulton Lincoln County War Archival Collection A/C 20060924.

Interview with Mrs. Tommy Powers Stamper by Leon C. Metz, 1968. "Interview no. 44," Institute of Oral History, University of Texas at El Paso.

Maurice G. Fulton Papers. Correspondence between Fulton and Walter Noble Burns. Special Collections, University of Arizona Library.

Nelson, Morgan, and Herman Weisner. "Don't Offend the Priests of Amun: An Analysis of the Teapot Dome Scandal and Albert B. Fall." 2012.

INDEX

ABOUT THE AUTHOR

J ohn LeMay is the author of *Tall Tales and Half Truths of Billy the Kid* and seven other history titles, including this one, on New Mexico and the Southwest. He is a past president of the Historical Society for Southeast New Mexico and lives in Roswell, New Mexico.